Whimsical Wa & How to Draw series

by karen campbell

wacky whiskers edition

Book 2

Dedicated to my own 3 munchkins...and their cats!

boring stuff & ode to cats!

I recently stumbled upon this quote:

"Every life should have 9 cats."

I couldn't agree more.
Here's to: Mitsy, Widget, Pepper, Beece,
Phoebe, Olivia, Tippie, Rosie and Zoe.
9 indeed. I hope to love 9 more!

Happy arting!

Tippie McGee (AKA Murder Cat)

Zooba

Rosie

Text and Illustrations Copyright © 2024 by Karen Campbell. All rights reserved.
Author, Illustrator, Publisher: **Karen Campbell, Artist, LLC** karencampbellartist.com
Editor: **Linda Duvel** (aka Grammar Grandma!)
Cover Design: **KT Design, LLC** ktdesignllc.com

This book has been exclusively designed to aid aspiring artists. Reproduction of work for at-home practice is permissible and encouraged! Any art produced, electronically reproduced, or distributed from this publication for commercial purposes is forbidden without written content from the publisher, Karen Campbell, Artist, LLC. If you would like to use material from this book for any purpose outside of private use, prior written permission must be obtained by contacting the publisher at karen@awesomeartschool.com. Thank you for supporting the author's rights. If you have purchased this book in error you can return it to Amazon for a full refund.

author's notes: helloooo!

Hi! I'm Karen Campbell and you may have discovered through my previous books that I have a watercolor addiction. And fun addiction too :)

Watercolor always gets a bad rap for being "hard". Lies! I promise that after you do at least 2 cats with me you'll quickly see that it's easy, fast, and fun!

While I'm a professional artist, I myself don't like to mix colors or fuss with color theory. To top it all off, I'm lazy and impatient! I like shortcuts and cheats and to make things quick and easy. I find when things are easy, I do them more, and the more I do them, the better I get at art! Wanna join me? YES!!

What does that mean for you and this book?
Buckle your seat belts and I'll tell you quickly (in case you're impatient too!).

- Every whimsical wacky cat in this book was painted with watercolors in only 1 or 2 coats (max) with colors straight from the pan!
- No mixing, blending, or boring, stressful color theory.
- Just get your brush wet, stick it into your watercolor pan, and paint. It's as simple as that.
- So, turn the page for a more in-depth look (and some of my best secrets) to making watercolor LOOK complicated even though it's truly not!

But first, let's start with the drawing...

A humble drawing suggestion!

To make it easy on yourself as you do your drawings, use a pencil for Figures 1, 2 and 3. I've had to draw mine in with pen in order for you to see them better but when I'm drawing "for real" I always use a pencil for the first three steps. THEN I like to do the final drawing (Fig. 4) in pen, OVER my pencil lines.

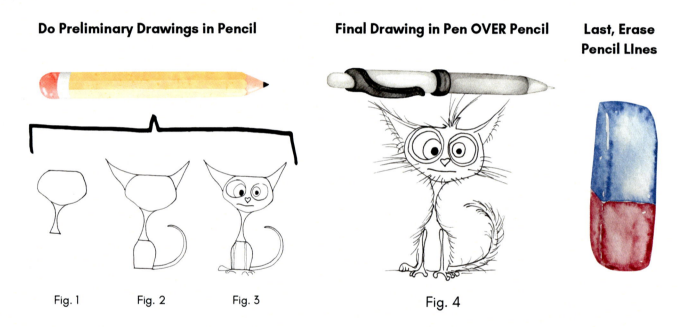

Do Preliminary Drawings in Pencil

Fig. 1 Fig. 2 Fig. 3

Final Drawing in Pen OVER Pencil

Fig. 4

Last, Erase Pencil LInes

Once I've drawn my lines in pen, I can erase my pencil lines. The main reason I'm making this suggestion is that often Figure 4 is just changing all of the outlines from smooth to squiggly! Or hairy! So drawing hairs in pen OVER a simple pencil outline becomes a cinch! Then all you have to do is erase all your unnecessary extra pencil lines and voila! You're done! This is true for ANY hairy beast when making that transition from smooooth pencil to hairy pen! What? Stop laughing! It's true!

art.awesomeartschool.com/wacky
to see EXACTLY what I mean as we draw and paint, together!

Now... my secret to no-stress painting Tip #1: use sets

It's the 21st century, my love, and brands have been working hard to create coordinating sets of watercolors filled with the most delightful choices! Peruse those art and craft store shelves and check out Amazon too! At the moment I'm obsessed with all the different Prima Watercolor Palette sets. I have been slowly collecting them all!

Skip the mixing (it's too fussy!) and just use the colors in pre-made sets!!

OR, simply stock up on individual colors you LOVE and that way you can't go wrong!

(Truly).

Just like packs of scrapbook paper, pre-made watercolor sets have been carefully chosen to coordinate with each other, leaving the guesswork, mixing and overwhelm behind! I love them so much that I used all my favorite sets to create the crazy cats in this book and the swatches shown on each page are my own! While I'm sponsored by lots of companies to test and report my findings across my YouTube channels, I'm not sponsored by Prima in any way. All the paint and supplies used in this book, I genuinely love and were purchased with my own money.

secret to no-stress Tip #2: how much water matters

With watercolors, it's the water that's in charge, not the paint. But learning to control it is pretty straightforward. The wetter your brush, the more diluted the paint will be. Paint coming on too strong? You just need to get some more water on your brush! Brush a sopping wet mess? Dab it onto your paper towels!

A **VERY WET** brush made this mark. I put my brush in my water and then dipped it STRAIGHT into the watercolor pan, and then onto the paper.

A **DAMP** brush made this mark. I wet my brush in my water and then PRESSED IT ONTO A PAPER TOWEL **FIRST** before dipping it into the watercolor and applying it to my paper.

A **DAMP** brush made this mark, just like the line before it. But then I added a **SECOND COAT** of the same color with a damp brush again. You can clearly see that two coats are darker than one.

That's as fancy as whimsical watercolor gets; isn't that incredible?! That means you can practice loads of Wacky Whiskers to get good, FAST. There's so little to master!

secret to no-stress Tip #3: paper towels

Paper and Paper Towels are your secret besties :) I actually keep a roll of paper towels on my art studio table at all times. I turn the roll on it's side and simply dab (or "doink" as I like to say in my videos) my brush <u>once</u> before I go to get my paint.

If your brush is way too juicy and drippy to control after you get your paint, dab it on the paper towels one more time. No joke. That will be the perfect amount of water for you to make all the quirky cats! You don't need to mix a thing and you don't need to do more elaborate brush to water dances. Just...

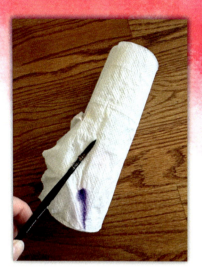

I don't throw the wet towels out either. The roll dries as is and I use it to "DOINK" my brushes to the perfect wet/dryness again the next day!

Save money and the environment :)

1. Wet
2. Dab
3. Dip
4. Optional Dab
5. Paint!

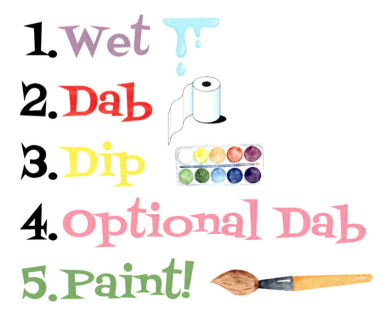

secret to no-stress Tip #4: paper & brushes

The only two items we haven't covered are the paper and brushes and those are just as important as everything else. For all the drawings in this book I used Hot Press watercolor paper by Fabriano.

I like to create my whimsical paintings on Hot Press paper because I find it a bit easier to DRAW on because it's so super smooth (I like to make things easy, remember?). Cold press watercolor paper will absolutely work too, it's just a bit bumpy so I find sometimes my lines don't come out as evenly.

But if Cold Press is all you have then go for it! It's better to work on what you've got than not work at all, so please use what you have!

Using the right brushes MADE for watercolors makes your life a whole heck of a lot easier too. I only use Polina Bright brushes but please use what you have quick and affordable access to. A simple waterbrush is perfect!!

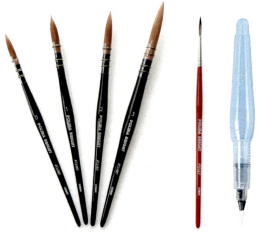

art.awesomeartschool.com/wacky you can find links to all of my favorite supplies, affordable alternatives (and a discount code for you too!)

do MORE with the help of fun gel pens!

A very important secret weapon in making your whimsical whiskered feline friends look pro is to use gel pens on top of your watercolors. With even just a few colors you can add wonderful and colorful details in making:

- Whiskers!
- Wispy Hairs!
- Toe-beans!
- Eyes, Nose, Mouth details!
- Any other scribbles you want to create. These are **PERMANENT** and therefore can be applied before OR after watercoloring which is fantastic! **The same is NOT true for the micro brush pens (next page)!**

Pentel gel pens!

secret tool no. 1

So how to use? First, not all gel pens are created equal. I find some brands work great and with other kinds, it's nearly impossible to get that ink flowing! I really like the gel pens by Pentel and Signo. They don't come in too many colors which I also like because sometimes too many can be overwhelming! And since we're only using these for details, we only need a few. Even just having a single black one can do SO much!

what about SUPER fine details?

On occasion it's really nice to draw a SUPER DUPER fine line. Personally, I really struggle with working small so instead of trying to apply watercolor and lines with a paint brush of normal size (or even an itty bitty brush), I instead reach for my...

secret tools no. 2 & 3

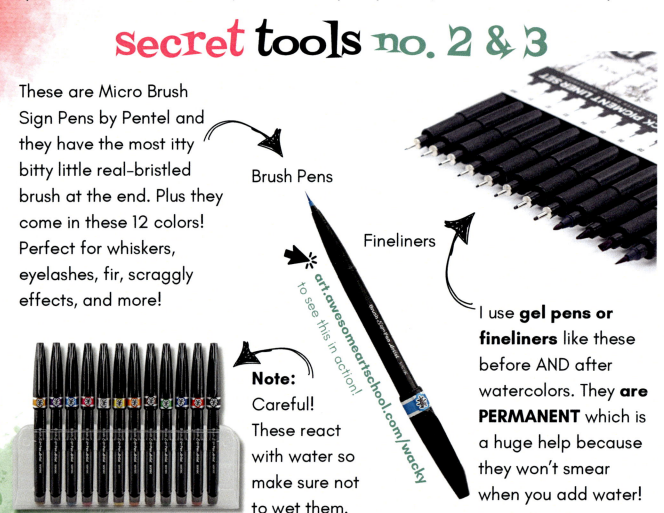

These are Micro Brush Sign Pens by Pentel and they have the most itty bitty little real-bristled brush at the end. Plus they come in these 12 colors! Perfect for whiskers, eyelashes, fir, scraggly effects, and more!

Brush Pens

Fineliners

Note: Careful! These react with water so make sure not to wet them.

art.awesomeartschool.com/wacky
to see this in action!

I use **gel pens or fineliners** like these before AND after watercolors. They **are PERMANENT** which is a huge help because they won't smear when you add water!

what about bold lines?

Sometimes the line of a gel pen or fineliners or micro brush pens are *too* fine. You're wishing you had a tool that would make a nice clean FAT line but would still have a brush nib so your strokes look natural and mimic that of a watercolor brush stroke. That's when I grab my...

secret tool no. 4

While it does claim to be permanent, to be on the safe side, I still only use this pen to fill in areas that need to be INK JET black AFTER I am done with watercolor.

Pentel Pocket Brush Pen

NO colored pencils?

You may wondering why I'm not mentioning colored pencils. That's because to me, these cats look way funnier and cuter when they're a little bit more rough-around-the-edges. Colored pencils tend to help smooth things over and patch mistakes, which goes against our edgy look of the cats we're creating together in this book! But you can still reach for them if you like! These are your creations, go for it!

so what's the biggest secret to making things look fancy?

So now you know the tools to make watercolors and add those squiggle and hairy edges. But we still need to add shading to take our creations to the next level. Even the silliest of cartoons benefit from shadows and depth. It's simply what takes your character from 2D to 3D. And all you need is a single soft:

secret tool no. 5

Pencil.

WOAH.

I KNOW.

Your pencil can truly be just a regular school No.2 pencil if that's all you got.

If you HAPPEN to have a softer pencil in your stash (like a 4B or higher) then great! Don't sweat it (or give up) if you don't. Any pencil will do.

I use a matte Blackwing pencil that is about equivalent to an 8B. Here's how I use it to bring magic to my watercolors.

how to make shading with just a pencil

You'll need to make a little scribble scrabble of graphite down on your paper first, like this:

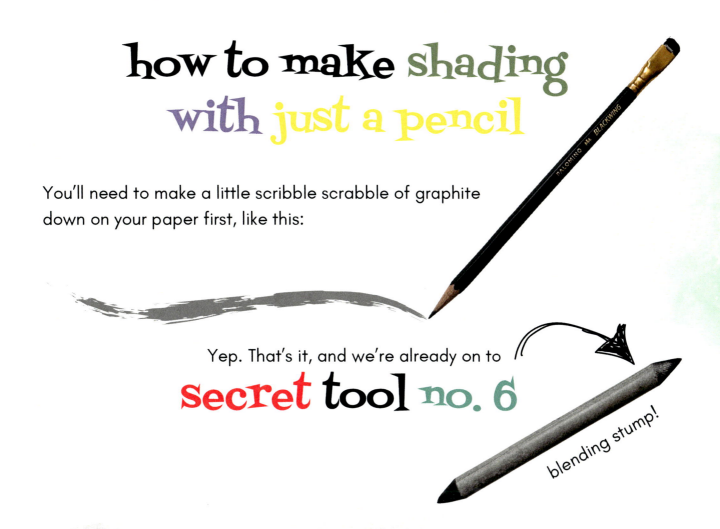

Yep. That's it, and we're already on to

secret tool no. 6

blending stump!

Now take a blending stump and smoosh that graphite scribble nice and evenly to get it all smoooothed out. This secret (and cheap) weapon creates lovely shading!

No blending stump? No worries. You can use a Q-Tip or simply wind a tissue around your finger and smoosh it that way. No excuses, you got this!

what about hightlights?

I cannot emphasize enough the pop and power of a white highlight. I find people are far too stingy with these! Personally, I cannot highlight enough! You can put one in the eyes, yes! But on cats and animals you can also use it to draw and doodle hairs and whiskers against darker colored watercolors.

these eyes are empty inside

these eyes are full of emotion!

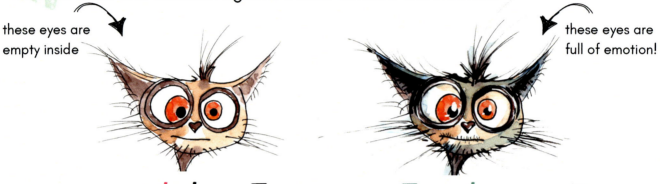

secret tool no. 7 (last one!)

Here are some of my favorite white-making tools. I'm absolutely addicted to the Copic white but the nail polish applicator makes it tricky to use. Posca's work amazing and the Gelly Roll is great for tiny highlights but it's often hard to get that ink flowing inside so a smaller nib Posca is easier (but comes with a higher price tag).

any ink or paint that makes an opaque mark will work!

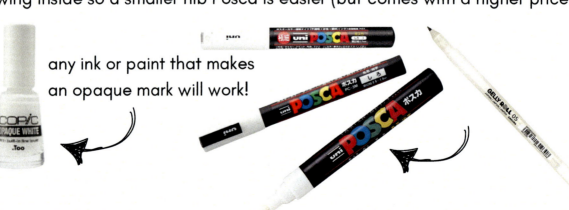

wish you could SEE how this all works?! no worries!

I made you a **free** Whimsical Watercolor full-length lesson that will walk you through my entire set up and how to use all the supplies. And brace yourself for fun because we'll also be drawing and painting this grumpy guy ... **TOGETHER**!!

art.awesomeartschool.com/wacky

Just type this link into your favorite browser to get started!

Now let's turn the page and start having some FUN!!

Let's make: stuck-up Sally

What you'll need besides a pencil and watercolor paper:

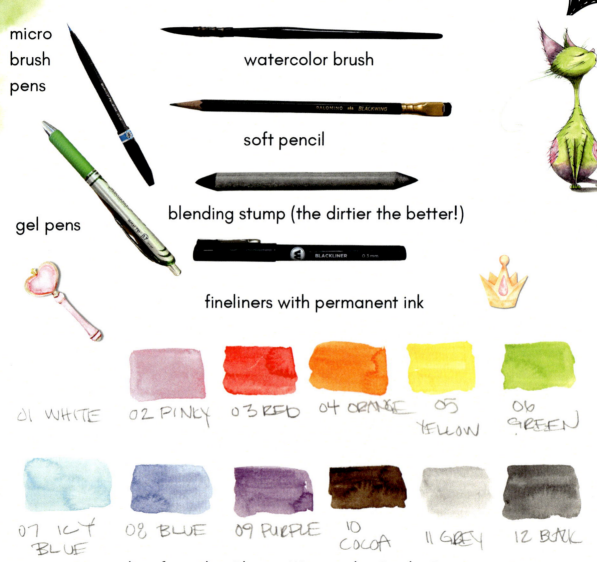

- micro brush pens
- watercolor brush
- soft pencil
- blending stump (the dirtier the better!)
- gel pens
- fineliners with permanent ink

01 WHITE 02 PINKY 03 RED 04 ORANGE 05 YELLOW 06 GREEN
07 ICY BLUE 08 BLUE 09 PURPLE 10 COCOA 11 GREY 12 BLACK

colors from the Classic Watercolor Set by Prima

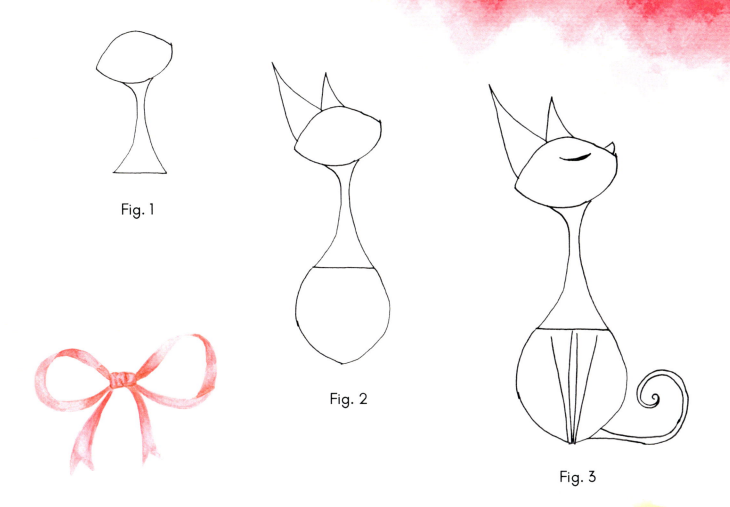

Fig. 1
Fig. 2
Fig. 3

Fig. 1 Draw a tilted almond shape and a long neck.
Fig. 2 Draw 2 pointy ears. One ear will be up on top and the other off to the side. Add a rounded belly that comes to a slight point at the bottom.
Fig. 3 Draw super skinny triangles for the legs and add a skinny, swirly tail. Add a very soft curve for the closed eye and make it thicker than the other lines. Add a wee nose right on top of the face, all the way over on the right side.

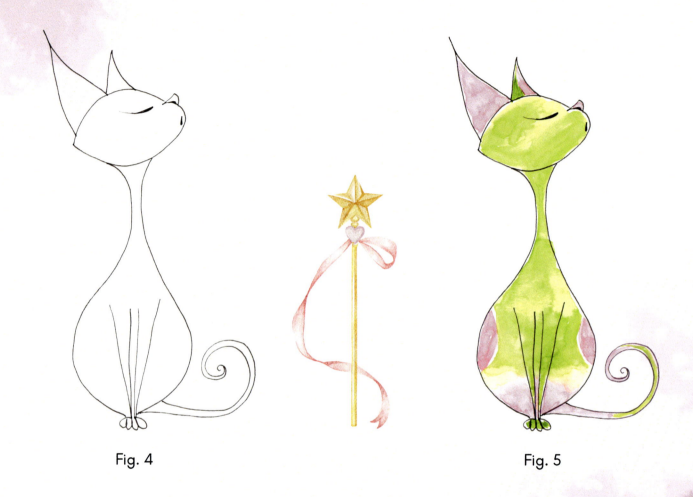

Fig. 4

Fig. 5

Fig. 4 Add some little loops for the feet! Then add a tear-drop shape for the tiny mouth as if she's whistling or saying a quiet "oh!". Erase the horizontal line.
Fig 5. Paint the ears, tail tip, and bottom one color. Add two spots on either side and paint them the same color. Let dry. Now paint everything else in a second color. Use the same colors I did or go your own way!

Ways to level-up Stuck-up Sally!

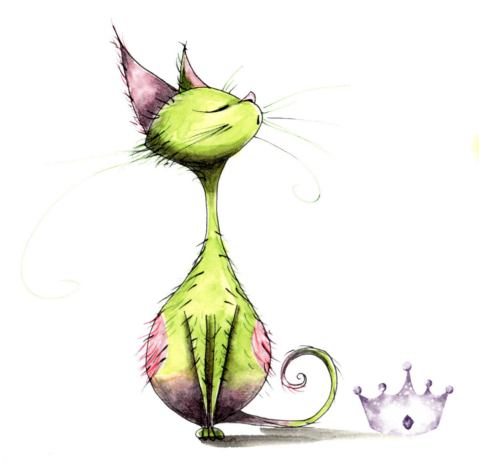

Final

Final With a soft pencil, scribble along the darker regions shown including along the jawline and neck, ears, bottom, and along the OUTSIDE of the little legs! Use a blending stump to smudge and smooth those pencil lines to form shadows. Use a gel pen and/or brush pen to add little hairs poking out every which way and wacky whiskers, of course! Or, skip the hairs to keep her tiny and smooth! Either way it's a win!

Let's make: Scraggly Simon

What you'll need besides a pencil and watercolor paper:

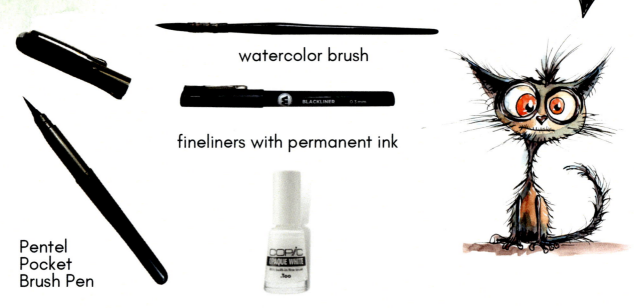

watercolor brush

fineliners with permanent ink

Pentel Pocket Brush Pen

white gel pen or ink for highlights

73 - TOKYO, 74 - ROME, 75 - AMSTERDAM, 76 - MAUI, 77 - JORDAN, 78 - CUSCO

79 - DUBAI, 80 - JAMAICA, 81 - LONDON, 82 - INCA, 83 - BUDAPEST, 84 - CALGARI

...and lots of colors from the Odyssey Watercolor Set by Prima

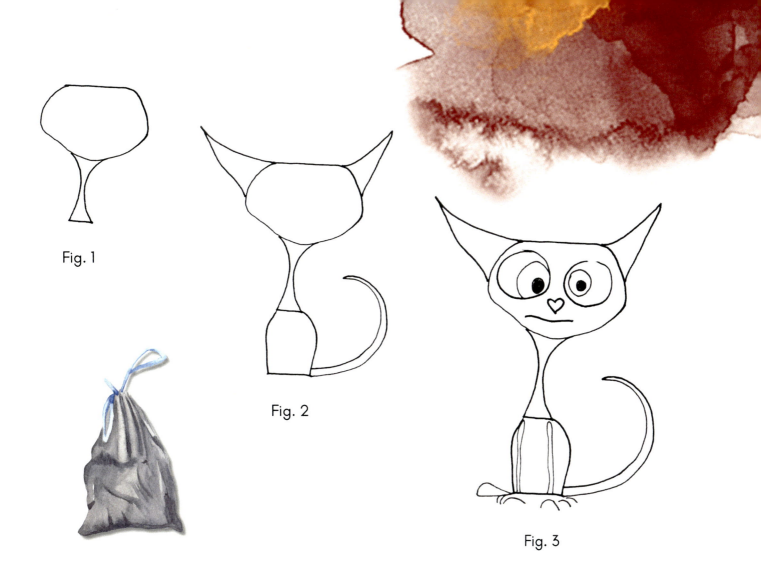

Fig. 1

Fig. 2

Fig. 3

Fig 1. Draw a big wonky circle for the head. Add a neck and make it super skinny in the middle!

Fig 2. Draw 2 pointy ears on either side of the head. Add a bell shape body and a pointy tail that shaped like a backwards "C".

Fig 3. Add simple eyes, a heart-shaped nose, and a straight-lined mouth. Add the skinniest legs in the whole wide world and wee curved lines for the toes.

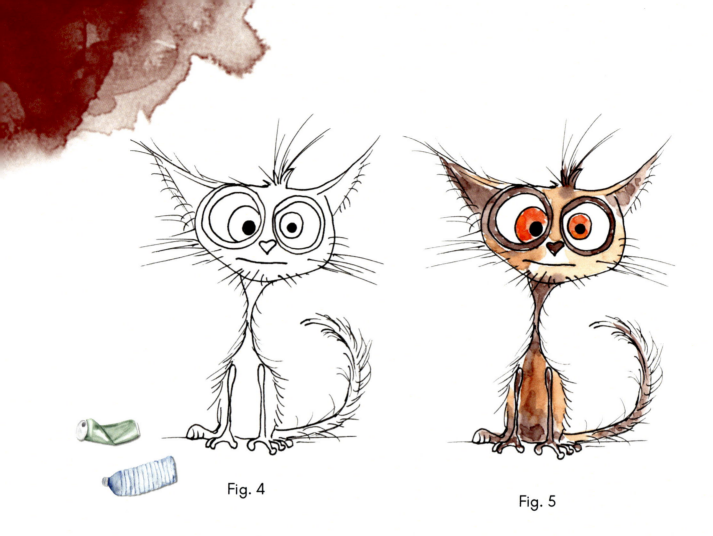

Fig. 4

Fig. 5

Fig 4. Make spiky hairs with a gel pen or fineliner all over!! Finish off those toes with little circles for the toe-beans! Add pupils. Erase all unnecessary pencil lines from the first steps.

Fig 5. Alternate two colors (here I used Cusco and Jordan) all over the body. Paint the eyes a third color. I kinda wish I had used blue!

Ways to level-up Scraggly Simon

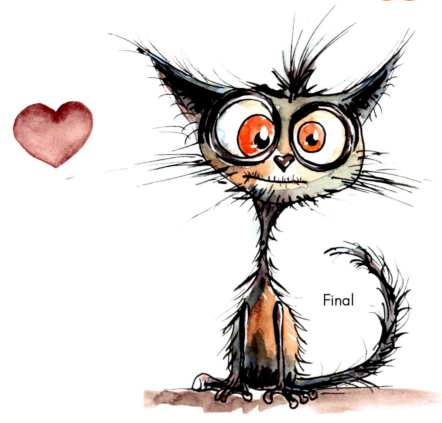

Final

Final Sweep blue in wide strokes over sweet scraggly Simon. Be inconsistent to make him look like more of a mess than he already is, even go outside the lines! Add tiny vertical marks with a teensy fineliner or brush pen (once the watercolor has dried) on his mouth. Add highlights to his eyes and all AROUND his eyes too. Give him a hug because he is clearly a mess (but it's not his fault)! lol

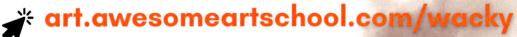

art.awesomeartschool.com/wacky

To see EXACTLY how to use ALL the pens to create this look!

Let's make: Sweet Sadie

What you'll need besides a pencil and watercolor paper:

watercolor brush

fineliners with permanent ink

white gel pen or ink for highlights

 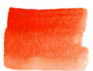 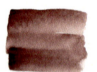 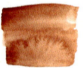

73-TOKYO 74-ROME 75-AMSTERDAM 76-MAUI 77-JORDAN 78-CUSCO

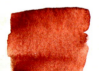 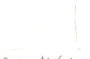

79-DUBAI 80-JAMAICA 81-LONDON 82-INCA 83-BUDAPEST 84-CALGARI

colors from the Odyssey Watercolor Set by Prima

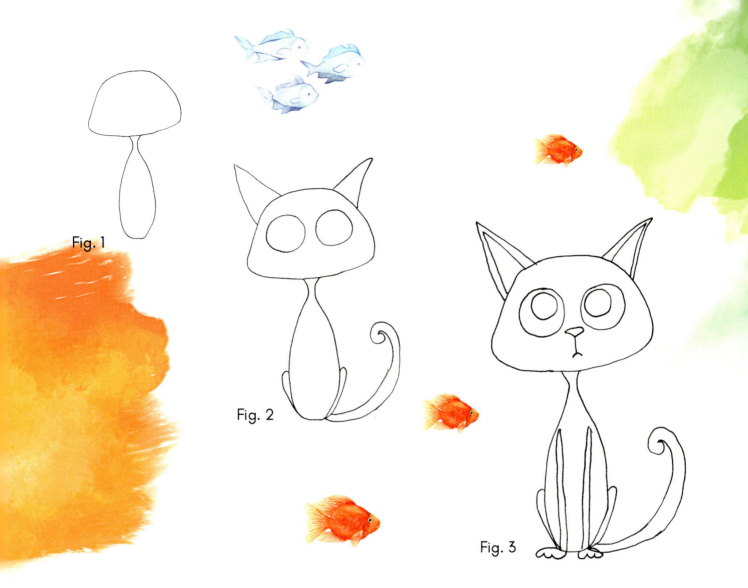

Fig. 1 Starting with little mushroom shape (right?!) for the head and body.
Fig. 2 Add 2 triangle ears, perfect circles right in the center of the head, 2 little bump outs for the legs and a curly tail.
Fig. 3 In the ears, add a second pair of triangles inside the first ones. Add 2 super long skinny front arms ending in bumps for paws. Finish with a cute nose and tiny frowny face.

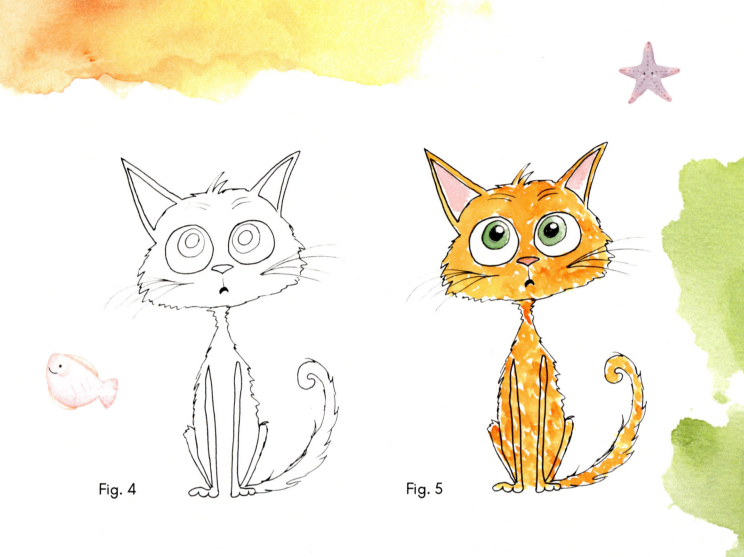

Fig. 4 Fig. 5

Fig. 4 Now switch to a pen and retrace the whole outline but make your line jaggy all the way around. Keep the lines around the front legs, eyes, and ears still clean and straight. Erase your pencil lines.

Fig. 5 Using yellow dapple around the entire body and head leaving lots of white spots! Paint the nose and ears a soft pink and color the eyes in any color you choose.

Ways to level-up Sweet Sadie!

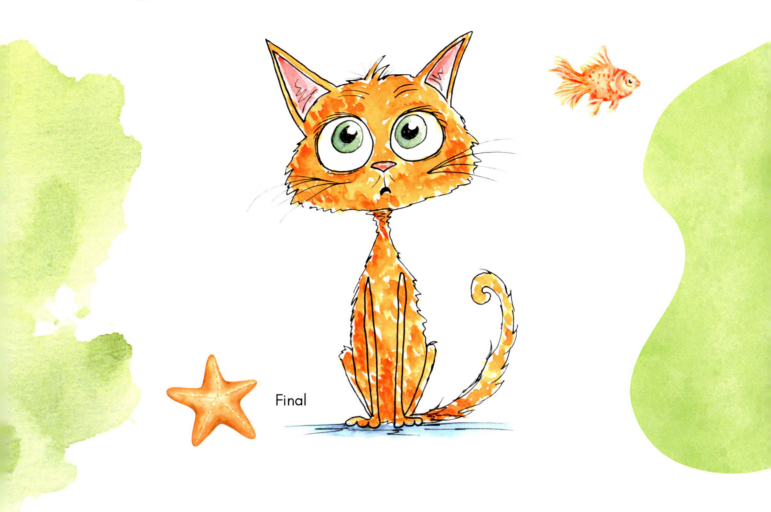

Final

Final Using the same paint color as the first layer, add another layer along the left side of the whole body and head. Also add a second layer just around the right cheek and bottom of the tail. Using your gel pen, add some scribbles to the tail, ears and face. As a final detail, add white highlights in the eyes to make her even more worried looking. Poor Sadie, it's okay!!

Let's make: Pissed-off Pete

What you'll need besides a pencil and watercolor paper:

- watercolor brush
- fineliners with permanent ink
- white gel pen
- black gel pen

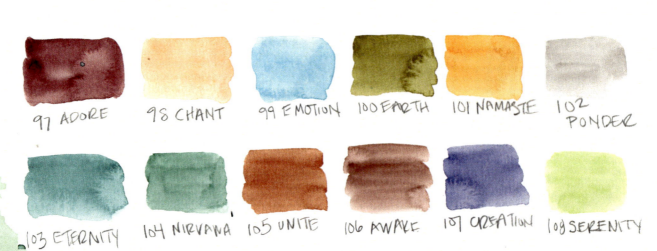

97 ADORE — 98 CHANT — 99 EMOTION — 100 EARTH — 101 NAMASTE — 102 PONDER

103 ETERNITY — 104 NIRVANA — 105 UNITE — 106 AWAKE — 107 CREATION — 108 SERENITY

colors from the Essence Watercolor Set by Prima

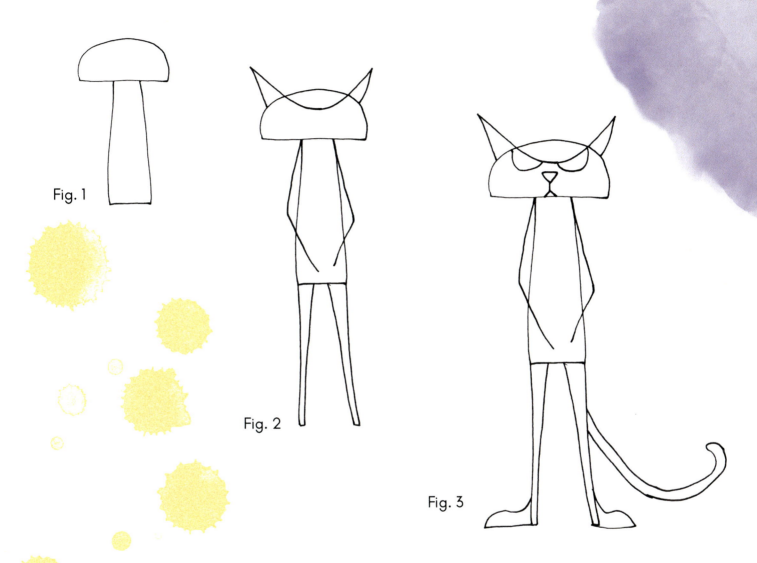

Fig. 1 Draw a simple mushroom shape (does it not look just like a mushroom?).
Fig. 2 Draw pointy ears connected by a swoop. Add 2 lines for each arm and long pointy legs that end in stumps.
Fig. 3 Add eyes to that head swoop, nose and mouth. Complete the feet and add a tail. Feel free to make it longer, shorter, or swirlier!

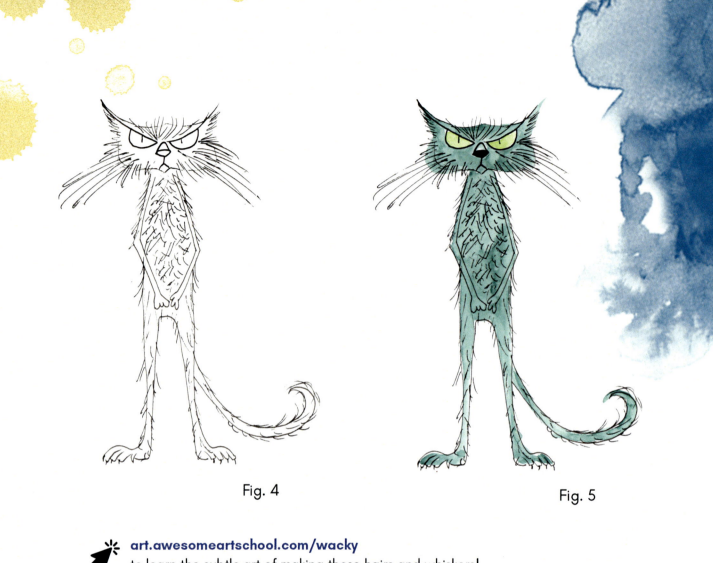

Fig. 4　　　　　　　　　　　　　　　　Fig. 5

art.awesomeartschool.com/wacky
to learn the subtle art of making those hairs and whiskers!

Fig. 5 Using a gel pen (NOT a brush liner as it will smear like crazy when you add the watercolors) scribble tons of hair all over and add pupils to the eyes.
Fig. 6 Sweep a solid color of watercolor over Pete's entire body. I used Eternity from Prima's Essence Palette. But ANY color would be cool! I painted his eyes in Serenity.

Ways to level-up Pissed-off Pete!

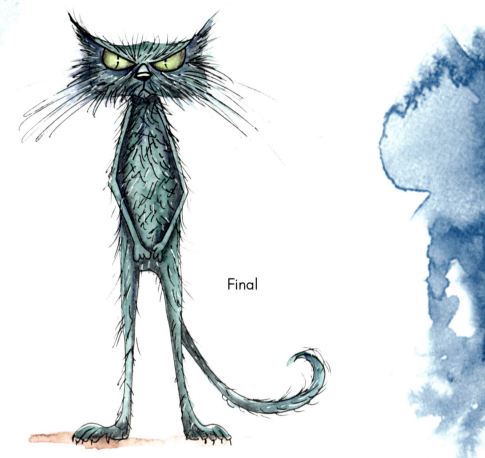

Final

Final Scribble the following areas with a soft graphite pencil: around his eyes and face, on the INSIDE of both arms, inside both legs, and on the base of the feet and tail. Now use a blending stump to smoosh your graphite lines to make shading. Do a wash of blue over him and go OUTSIDE the lines! Scary but so fun! Using a black gel pen, make even MORE whiskers! Using a white gel pen, add little strokes and highlights over the fur, across the pupils and on the nose. SO FUN!!!!

Let's make: Contented Carl

What you'll need besides a pencil and watercolor paper:

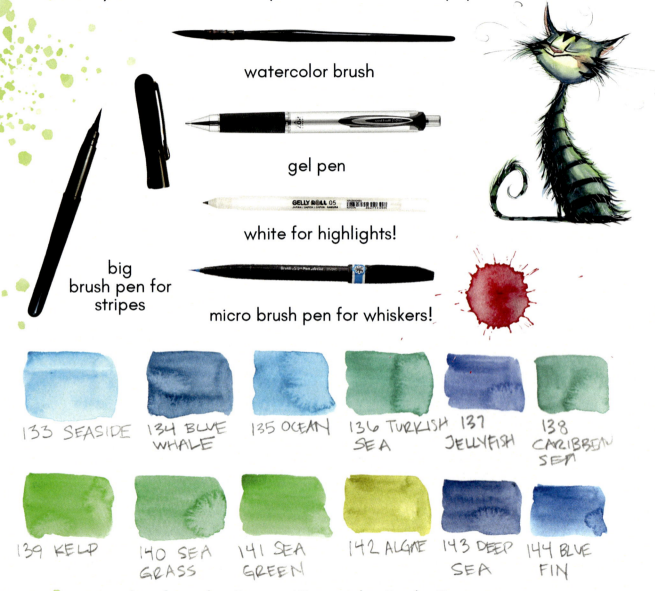

- watercolor brush
- gel pen
- white for highlights!
- big brush pen for stripes
- micro brush pen for whiskers!

133 SEASIDE | 134 BLUE WHALE | 135 OCEAN | 136 TURKISH SEA | 137 JELLYFISH | 138 CARIBBEAN SEA

139 KELP | 140 SEA GRASS | 141 SEA GREEN | 142 ALGAE | 143 DEEP SEA | 144 BLUE FIN

colors from the Current Watercolor Set by Prima

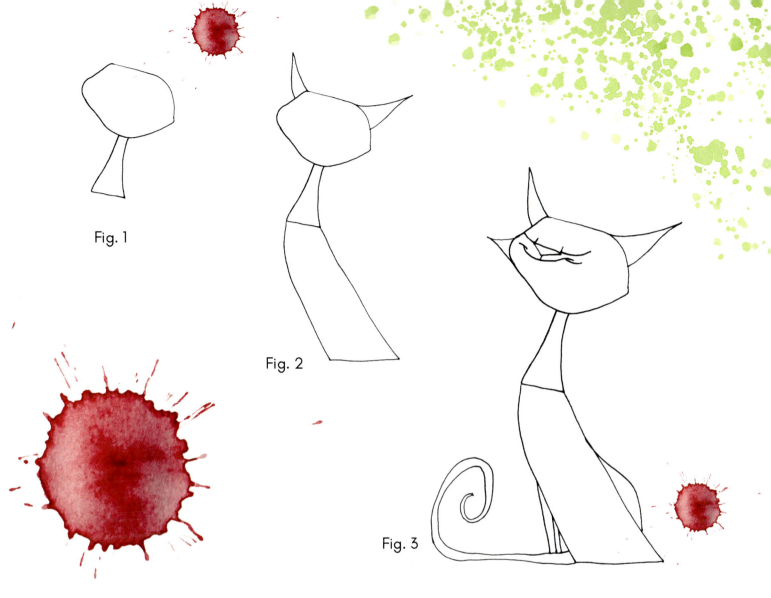

Fig. 1 Draw a big wonky head leaning off to the right. Add a wonky neck to go with.
Fig. 2 Draw big ears on either side and then add on a longer body portion.
Fig. 3 Add a triangle off the left cheek and a face way off to the left too. Add a little bump out for the rear and a long curly tail. Add 2 skinny legs.

art.awesomeartschool.com/wacky
To see EXACTLY how to go from Fig. 3 to 4 with ease!

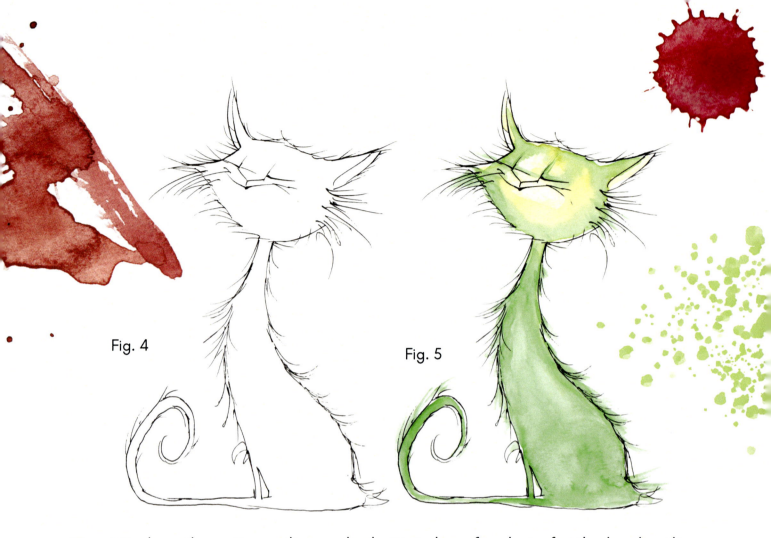

Fig. 4 Redraw the entire outline and substitute long fine hairs for the hard outline. Use a gel pen for this step and your lines won't move when you add the watercolors in the next step.

Fig. 5 Coat the face in a light color (I used Algae from the Current set). Then while that's still wet, brush a layer of light green over the entire body. Add the same green around the head but keep the middle portion (by the face) the light color. Let dry. Final With a dark blue, paint around the face and along the front half of the body and along the tail. Let dry.

ways to level-up Contented Carl!

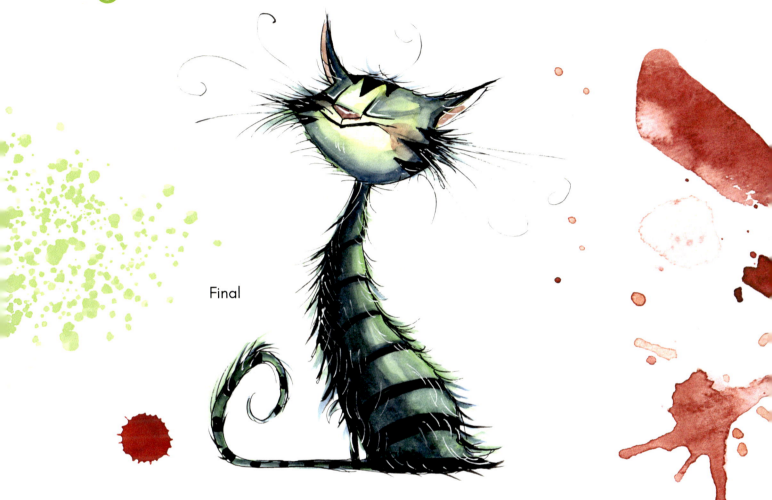

Final

Final Cont. Use the Pocket Pentel brush pen to add stripes along the back, tail and on either side of the face. Let dry. Steal a blush color from another set and add cheeks, a nose and the inside of his ears. Finish off by making giant swirly whiskers with the micro brush pens and white individual hairs everywhere. Finally, add a white highlight to the nose and eyes. Sooooo cute and contented!

Let's make: off-Kilter Kevin

What you'll need besides a pencil and watercolor paper:

watercolor brush

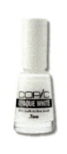
strong white for big eye highlights!

black gel pen

Pentel Pocket brush pen

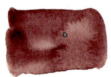 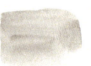
97 ADORE · 98 CHANT · 99 EMOTION · 100 EARTH · 101 NAMASTE · 102 PONDER

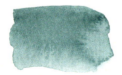 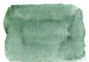
103 ETERNITY · 104 NIRVANA · 105 UNITE · 106 AWAKE · 107 CREATION · 108 SERENITY

colors from the Essence Watercolor Set by Prima

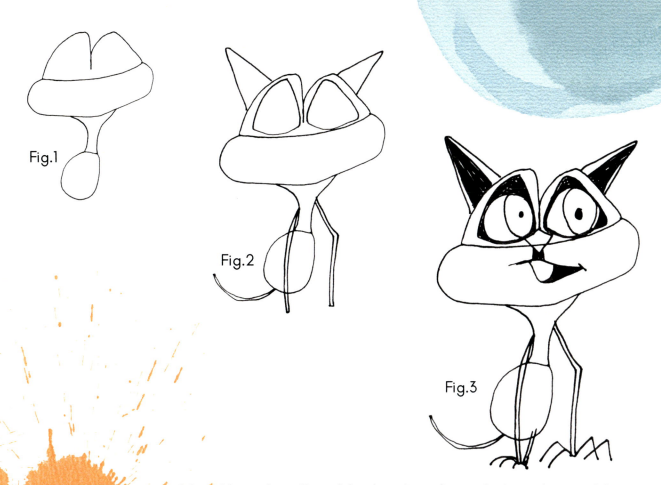

Fig. 1 Draw 2 bumps (that like a bum!). Add a hotdog shape below that. Add on a funnel shape for the neck and then add a lumpy oval underneath.

Fig. 2 Add triangles for ears and even 2 triangles in the eyes! Add 2 super duper skinny arms, the right one looking kinda broken! Add a skinny tail.

Fig. 3 Fill in the ears with black ink. Then draw circles for the eyes and fill in all the area around them (inside the eye triangles from Fig. 2). Draw a diamond shape nose and copy the mouth as best you can. I make some areas black to make it easier to see. Lastly, add on those crazy spider toes! All of this so far should be in pencil.

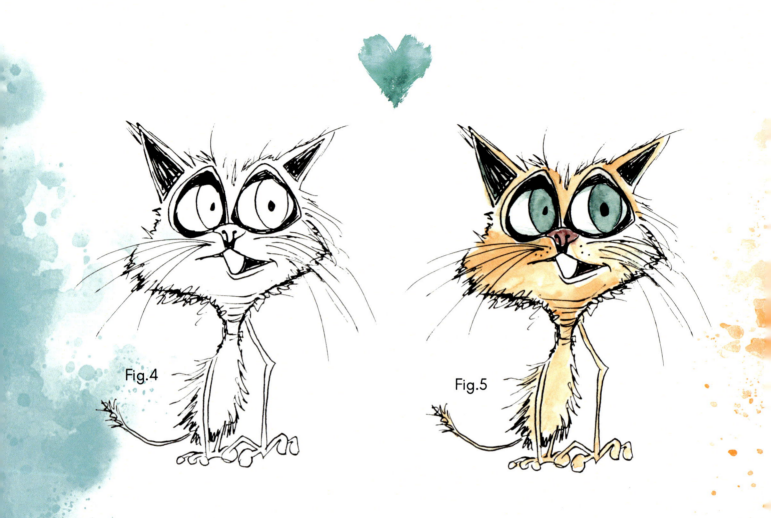

Fig. 4 Here's where you will want to take my suggestion from the front part of the book and switch from pencil to pen. With your gel pen, make loose scribbly lines all around the entire body, head and tail. Finish off the toes with balls (representing those cute toe beans) and add some more longer whiskers. Those solid black fill in areas can become squiggles with your pen in this stage! He is fast and loose!

Fig. 5 Wash a layer of Chant over his whole body, Awake on his nose and Eternity in his eyes (sounds so dramatic!). Let dry. Add Namaste in random places around his face and body. Let dry.

Ways to level-up off-kilter Kevin!

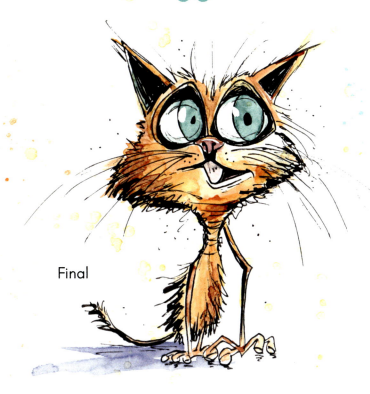

Final

Final Add brown to the left side of his face and in random places around his fur. Add big circles of white in his eyes. While your brush is wet and loaded, make splashes all around. Let it all dry. With the gel pen, make more scribbles around his face and draw circles in the whites of his eyes. Make little dots all around. Now take the Pentel Pocket brush pen and make small squiggles just around the edges everywhere. Gift this guy to someone special in your life. He needs it as much as your friend!

Let's make: Pretty Penny

What you'll need besides a pencil and watercolor paper:

a good white!

watercolor brush

soft pencil

blending stump (the dirtier the better!)

fineliners with permanent ink

13-ISLAND 14 COCONUT 15 HURRICANE 16 PARROT 17 HIBISCUS 18 PALMS

19 PITAYA 20 REEF 21 PINEAPPLE 22 SUNSET 23 OCEAN 24 TIKI

colors from the Tropical Watercolor Set by Prima

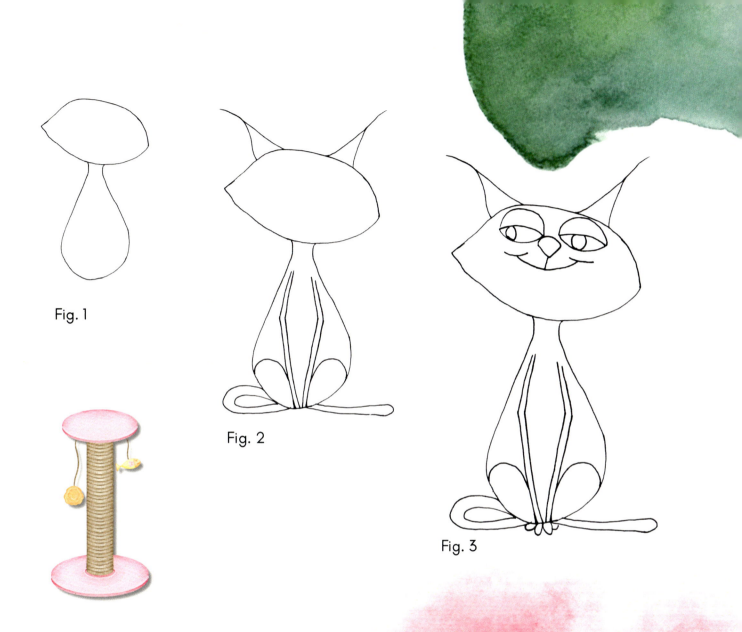

Fig. 1 Draw a lemon shape for the head. Add a rounded body.
Fig. 2 Add 2 triangle pointy ears, super skinny arms, looped legs and a simple tail.
Fig. 3 Add little toes off the arms/legs and a happy face!

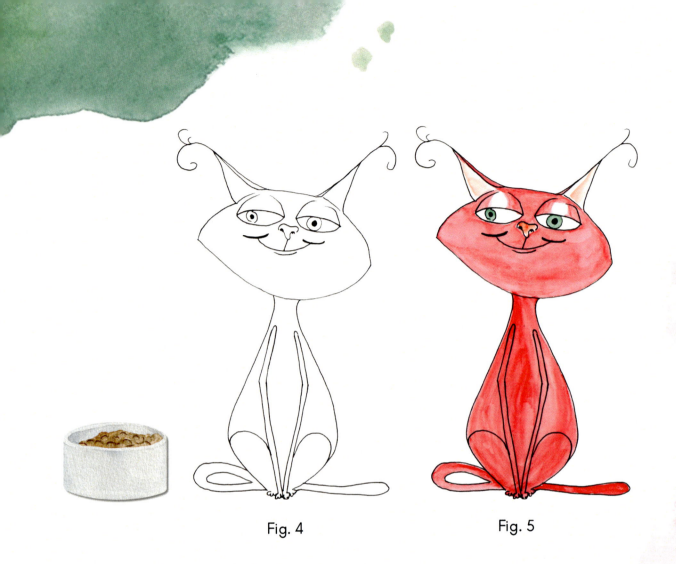

Fig. 4

Fig. 5

Fig. 4 Fine tune the eyes by adding pupils and make the ears a tad more ornate just for fun.

Fig. 5 Sweep pink over her entire body from head to toe. Paint in the eyes, nose, and ears.

Final Paint stripes down her entire body and all around her face. Then sweep a second layer of body color along the right side of her face and body. Let dry.

Ways to level-up Pretty Penny!

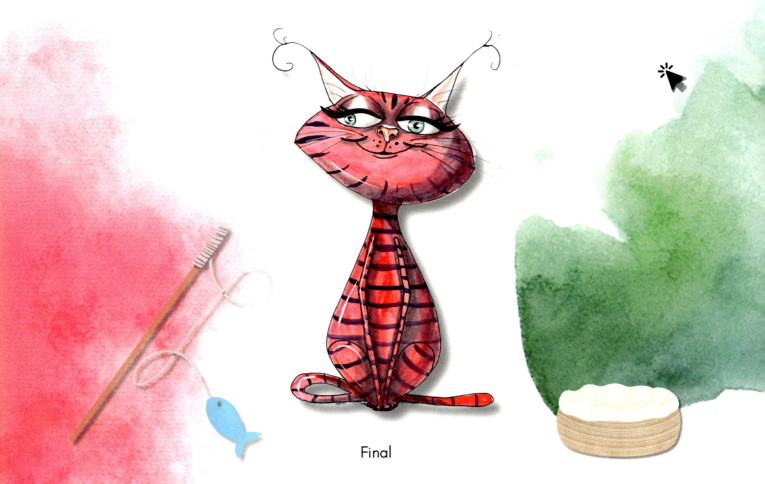

Final

Final With a soft pencil, make light sketches around her eyelids, eyes and along the right side of her body and both arms. Then take a blending stump to smooth all of the graphite out so it just looks like shading and you can't see the sketch marks anymore. With the Pentel Pocket brush pen, create cat eye make up! Finally, using white, create highlight streaks on the left side of all of her features from her eyes down to her tail! Isn't she so pretty!?

Let's make: Nightmare Nico

What you'll need besides a pencil and watercolor paper:

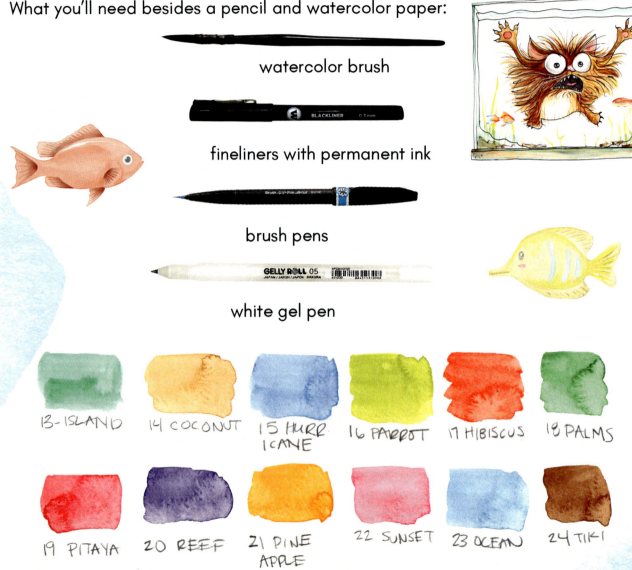

- watercolor brush
- fineliners with permanent ink
- brush pens
- white gel pen

13 - ISLAND
14 COCONUT
15 HURRICANE
16 PARROT
17 HIBISCUS
18 PALMS
19 PITAYA
20 REEF
21 PINEAPPLE
22 SUNSET
23 OCEAN
24 TIKI

colors from the Tropical Watercolor Set by Prima

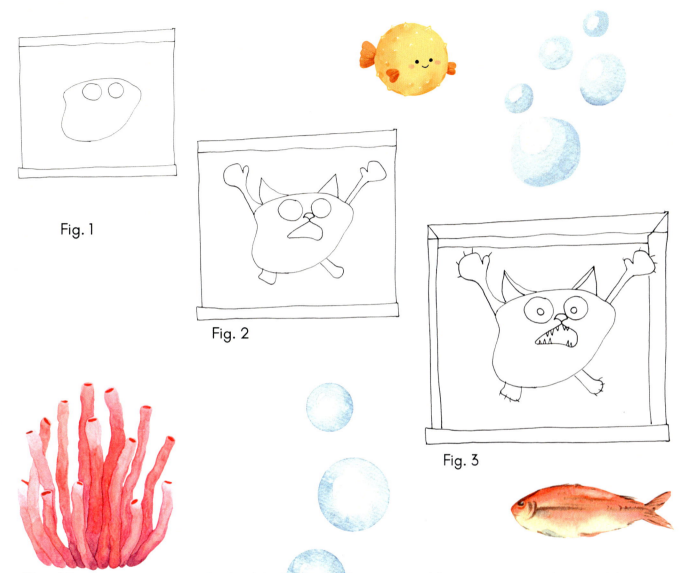

Fig. 1
Fig. 2
Fig. 3

Fig. 1 Draw a square with double lines at the top and bottom. Next, draw a blob with two biggish circles at the top.

Fig. 2 Draw 2 triangle ears with boxing glove shapes on either side. Then add a small nose, wonky open mouth and 2 basic feet shapes coming off the bottom.

Fig. 3 Add claws, teeth, pupils, and more details to the ears.

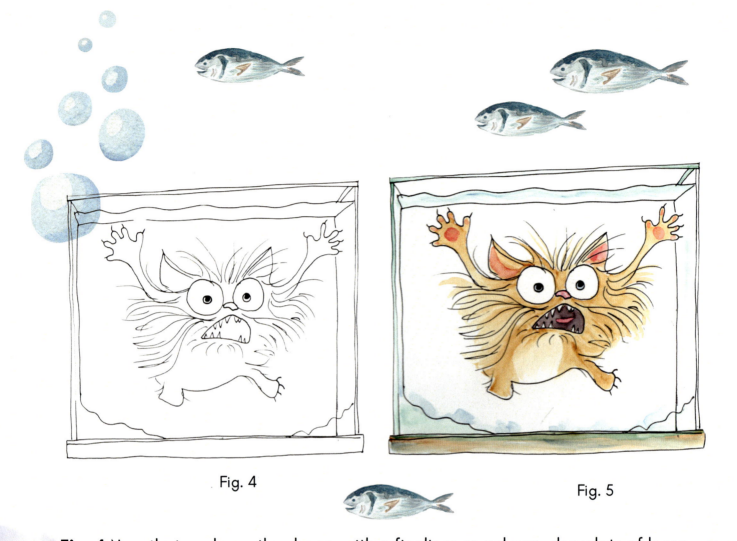

Fig. 4

Fig. 5

Fig. 4 Now that we know the shape, with a fineliner or gel pen, draw lots of loose individual long hairs coming from the face area and extending out just past the outline of the body. Feel free to make them even longer if you like! When all the fur has been drawn, you can erase most of the original body outline leaving only the bottom (between the legs). Add some wavy lines to the top and bottom of the tank.

Fig. 5 Sweep light brown over the entire body, pink to the paws, ears, nose and tongue. Let dry. Add a second layer of brown around the face and legs, leaving the belly lighter in color. Paint the inside mouth a dark color. Let it all dry.

Ways to level-up Nightmare Nico!

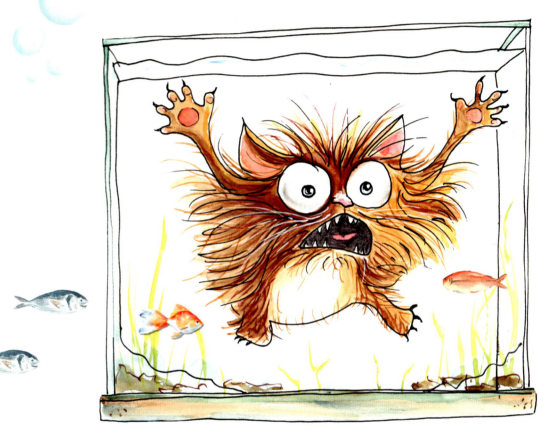

Final

Final With the darkest brown shade, paint a third layer around mostly just the left side of poor, trapped Niko. Then with the fineliners in beige and brown, make many many more hairs all around him. Doodle some watercolor fish and some more sand and plantlife for extra fun!! Gift to a friend for a good, hearty laugh!!

Let's make: Fretful Frida

What you'll need besides a pencil and watercolor paper:

watercolor brush

soft pencil

blending stump (the dirtier the better!)

fine liner

Pentel brush pen for outlines

strong white for big eye highlights!

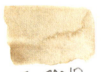
85 SAND RIDGE

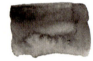
86 SHADOW

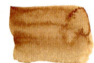
87 CAVERN

88 FOX BERRY

89 POND

90 STREAM

91 BEAR

92 MIST

93 GREY STONE

94 DAY LIGHT

95 RED WOOD

96 DEEP MOSS

colors from the Woodlands Watercolor Set by Prima

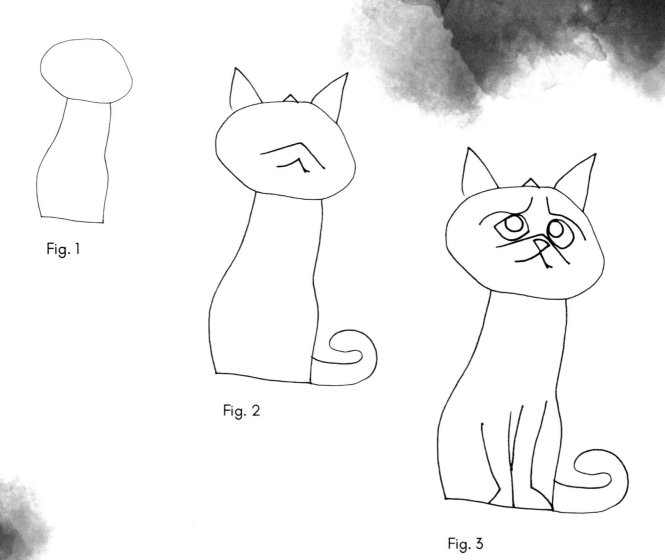

Fig. 1
Fig. 2
Fig. 3

Fig. 1 Draw a wonky oval shape and add a long, wonky rectangle for the body.
Fig. 2 Make 2 large triangles for ears at the top of the head followed by 3 inverted "V" shapes for the hair, nose, and muzzle.
Fig. 3 Now add simple front legs, eyes, eyebrows, nose, and tail.

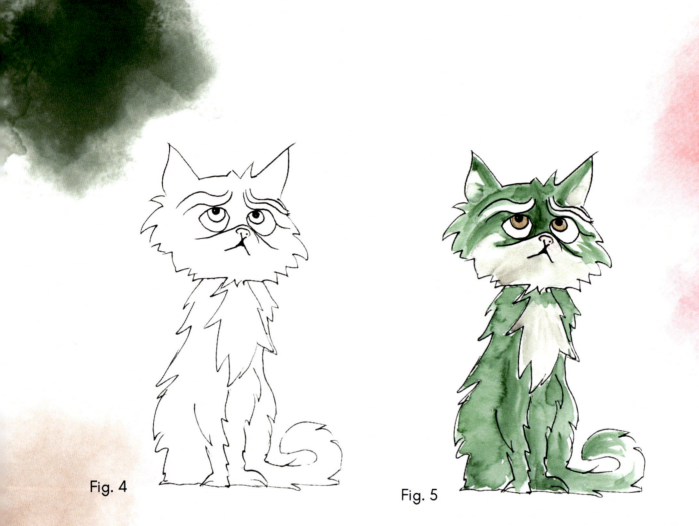

Fig. 4

Fig. 5

Fig. 4 Now using a pen, go around the entire body making jagged lines where the smooth lines once were. Erase the smooth lines when you're done. Make a front scraggle area in the shape of a man's tie at the chest. Color in the pupils.

Fig. 5 With green (or any color of your choice), paint in all the areas except the chest, ears, muzzle, eyebrows, and part of the tail. On those areas paint in with a lighter/different color.

Ways to level-up Fretful Frida!

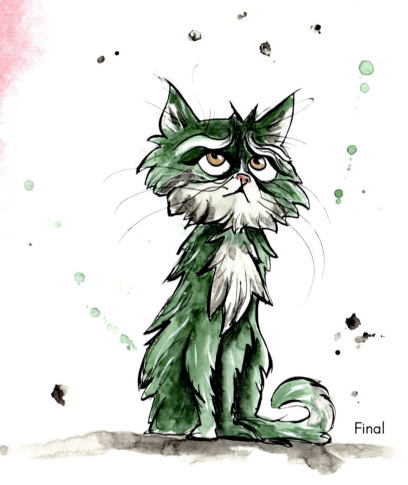

Final

Final Paint a second coat of green around the chest, between the eyes, and on both sides of the legs. With a darker grey, paint around the edges of the lighter areas. Draw super fine, longer whiskers with a fine liner or gel pen and then outline the whole cat using the larger Pentel Pocket Brush Pen. Add daps of white highlights in the eyes and around the fur. Finish by splashing the watercolors all around her.

Let's make: Sexy Sam

What you'll need besides a pencil and watercolor paper: micro brush pen for whiskers!

gel pen

watercolor brush

soft pencil

blending stump (the dirtier the better!)

micro brush pen

fineliners with permanent ink

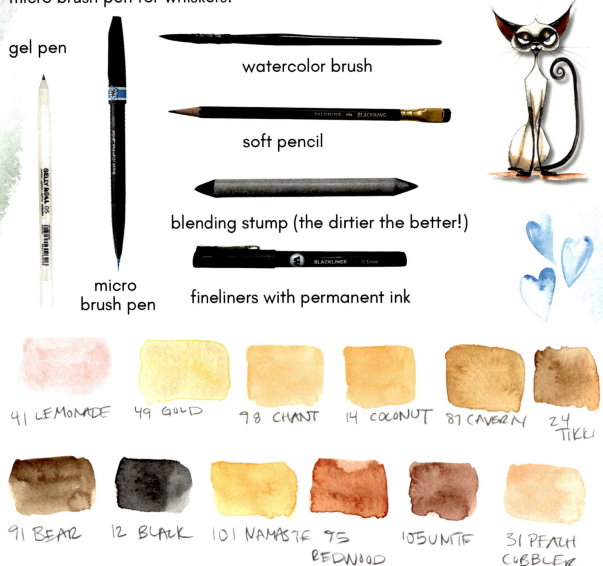

- 41 LEMONADE
- 49 GOLD
- 98 CHANT
- 14 COCONUT
- 87 CAVERN
- 24 TIKKI
- 91 BEAR
- 12 BLACK
- 101 NAMASTE
- 95 REDWOOD
- 105 UNITE
- 31 PEACH COBBLER

colors from the Complexion Watercolor Set by Prima

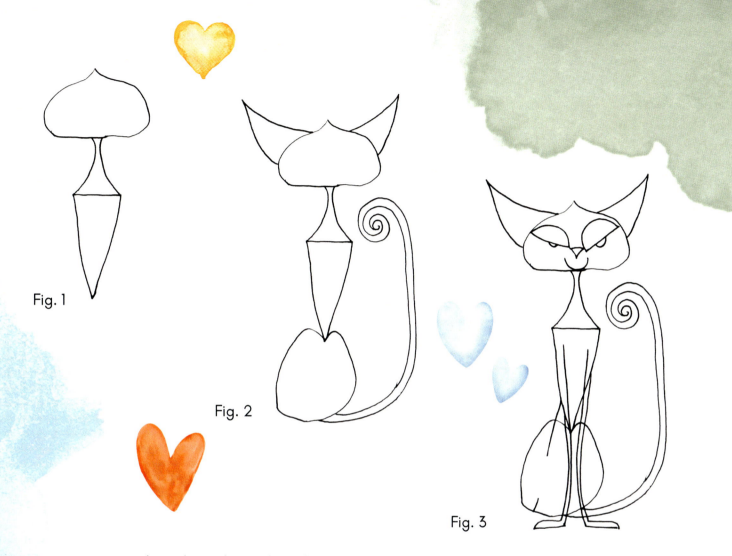

Fig. 1
Fig. 2
Fig. 3

Fig. 1 Draw a dumpling shape head (I mean, right?) followed by an inverted cone. Attach to that a long triangle and you're ready to roll!

Fig. 2 Add 2 big ears. Now make a big blob shape for the lower body only make sure the left side is larger than the right. Now add that long, loopy tail!

Fig. 3 Add 2 super long skinny arms straight downwards, ending in long, flat feet going in opposite directions. Add the basic face shapes and 2 skinny arms and long narrow feet.

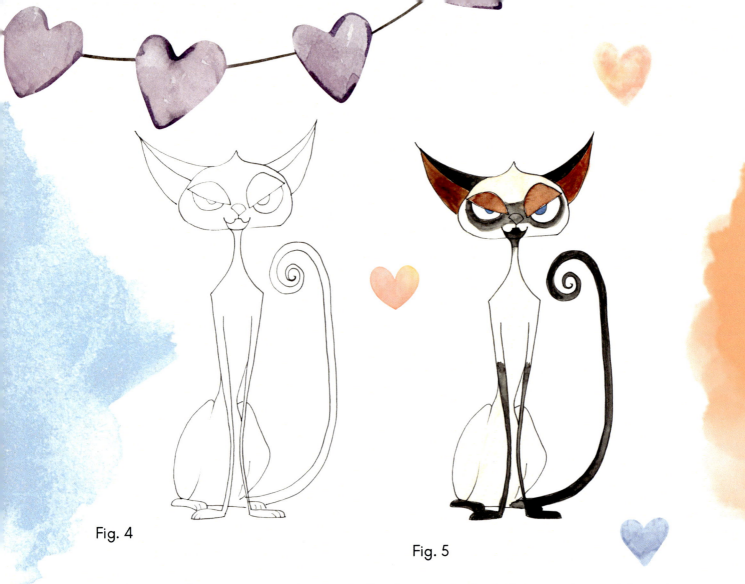

Fig. 4

Fig. 5

Fig. 4 Now redraw our Sexy Sam in a fineliner to refine things a bit, adding the lower portions of the droopy eyes and the details in the feet. Add folds to ears
Fig. 5 Paint the entire body and head with a watered down brown (Cavern). Let dry. Now paint the feet, tail, arms, top of ears, around the eyes black. With a medium brown color (Redwood), paint the eye bulges and inner ears. Using a blue micro brush pen, color in the eyes.

Ways to level-up Sexy Sam!

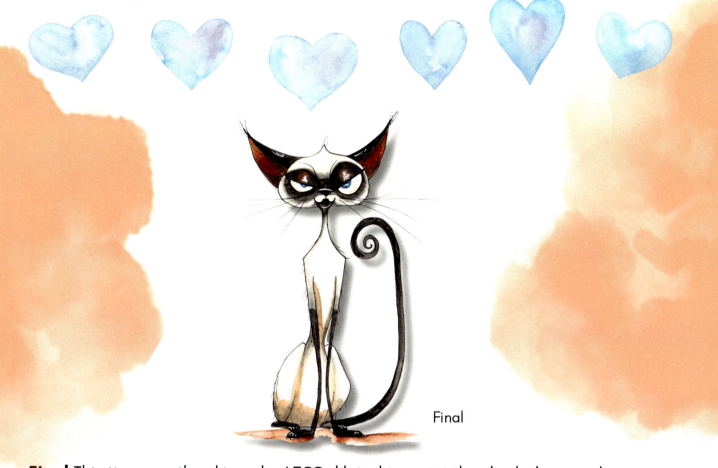

Final

Final This time use the skin color LESS diluted to paint the shaded areas shown (basically towards the bottom and inside the arms). The rest of the work is all done with the soft pencil! Scribble around the eyes, ears, upper arms and along shaded regions. Then take a slender blending stump and moosh it to make it smooth and blended into the watercolors. Lastly, use the white gel pen to add highlights to the eyes, ears, pupils and toes!! Oh Sexy Sam what trouble are you cooking up?? Try this in Magenta for a hot Samantha! Bet she'd be FABULOUS!

Let's make: Baby Boo

What you'll need besides a pencil and watercolor paper:

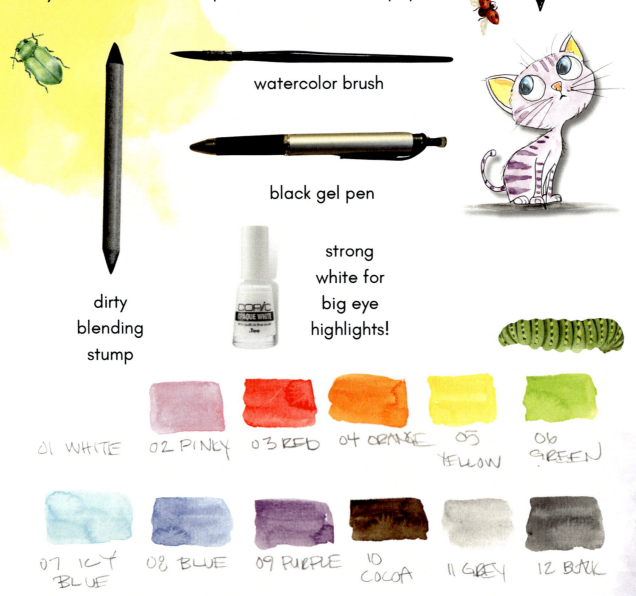

watercolor brush

black gel pen

dirty blending stump

strong white for big eye highlights!

01 WHITE 02 PINKY 03 RED 04 ORANGE 05 YELLOW 06 GREEN

07 ICY BLUE 08 BLUE 09 PURPLE 10 COCOA 11 GREY 12 BLACK

colors from the Classic Watercolor Set by Prima

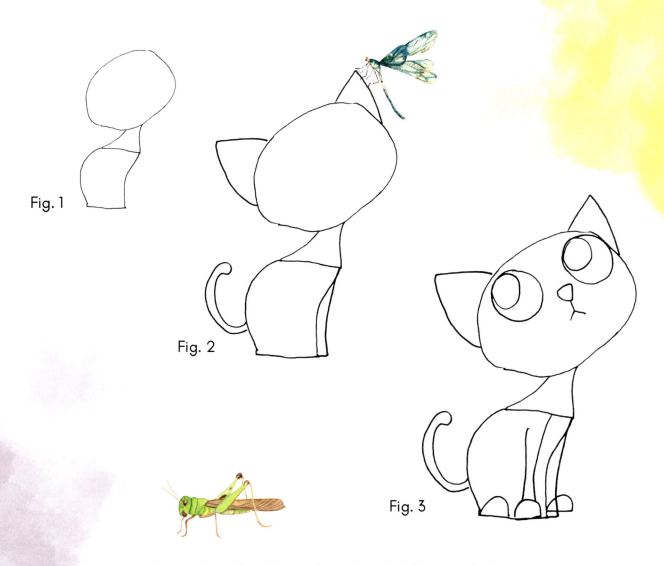

Fig. 1 Draw an wonky oval and a slanted neck. Add the simple body shape.
Fig. 2 Add 2 little triangle ears. Make sure one is almost on top of the oval so that the head will look upturned when finished. Add a tail and another line off the body for the front leg.
Fig. 3 Add half-circles for the feet, the eyes, nose and wee down-turned mouth.

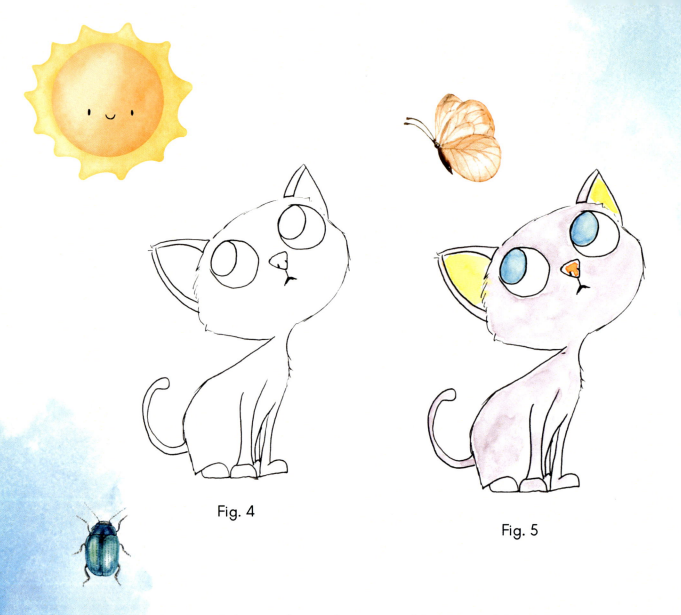

Fig. 4

Fig. 5

Fig. 4 Now redraw with her with a gel pen. Feel free to add little furry bump outs around the head and chest. Make as many or as few as you like!

Fig. 5 Paint her all over in pink. Make the ears yellow, nose orange, and eyes blue (or go your own way with the colors!). Let dry.

Ways to level-up Baby Boo!

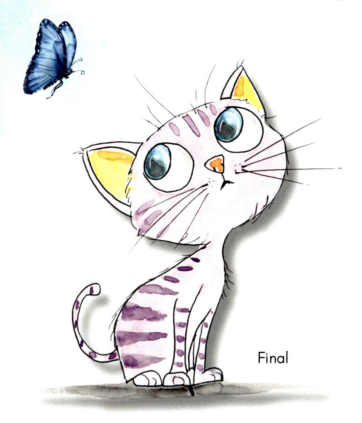

Final

Final Using the purple watercolor, add stripes over the back, down the arms and tail, and on the face. Paint an orange stripe at the tops of the ears. Paint the bottom of the eyes in black. Use a dirty blending stump to add shading on the white parts of her wide eyes and around her body. With a gel pen, add whiskers on her head, and shooting out on either side of her cute nose. Lastly, use some white to paint long reflections in her eyes. That subtle twinkle adds so much to bring her to life! I hope she's able to catch that butterfly; she seems awfully worried about it!

Let's make: Shady Slim

What you'll need besides a pencil and watercolor paper:

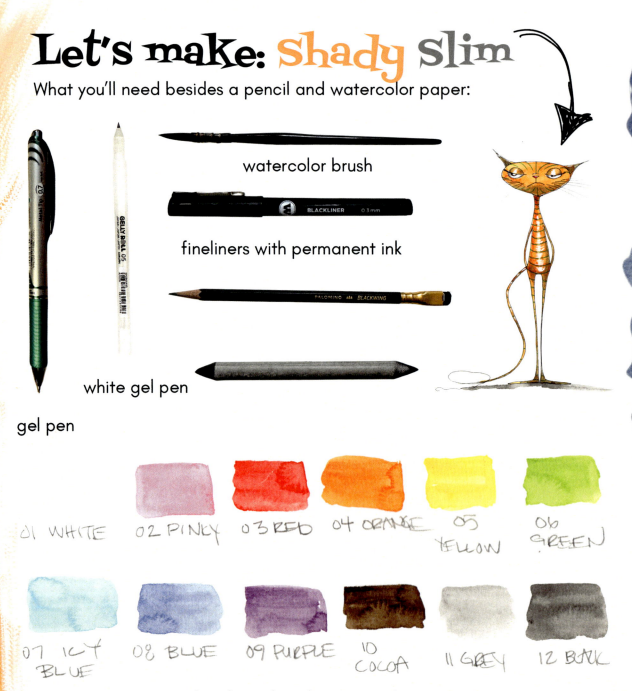

watercolor brush

fineliners with permanent ink

white gel pen

gel pen

01 WHITE 02 PINKY 03 RED 04 ORANGE 05 YELLOW 06 GREEN

07 ICY BLUE 08 BLUE 09 PURPLE 10 COCOA 11 GREY 12 BLACK

colors from the Classics Set by Prima

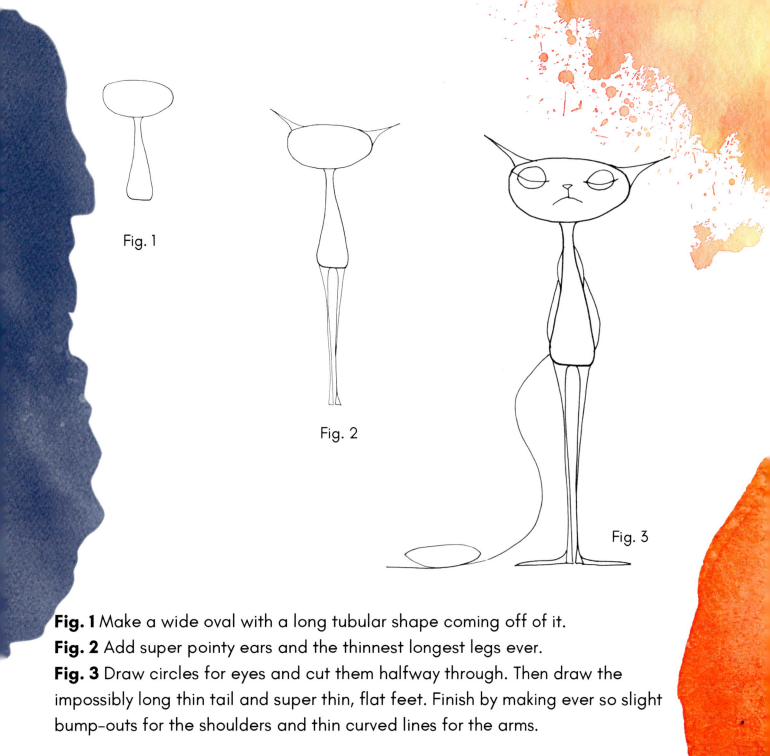

Fig. 1 Make a wide oval with a long tubular shape coming off of it.
Fig. 2 Add super pointy ears and the thinnest longest legs ever.
Fig. 3 Draw circles for eyes and cut them halfway through. Then draw the impossibly long thin tail and super thin, flat feet. Finish by making ever so slight bump-outs for the shoulders and thin curved lines for the arms.

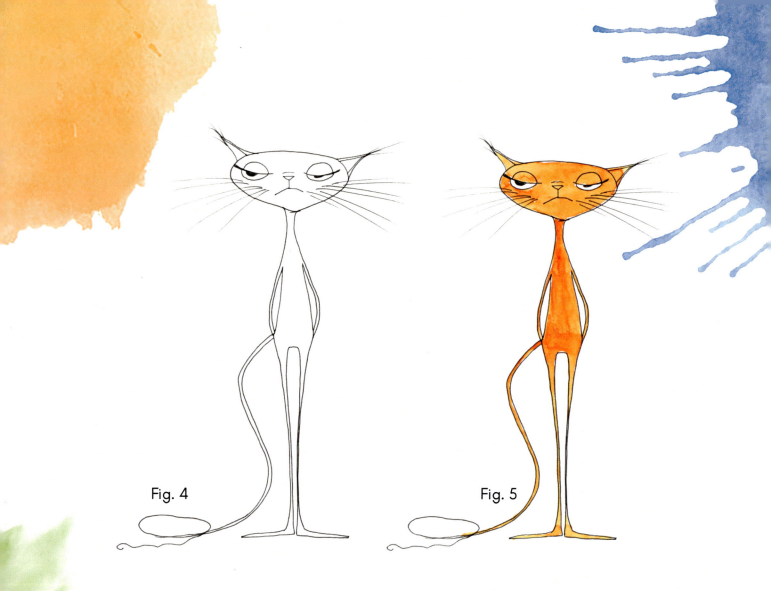

Fig. 4 Fig. 5

Fig. 4 Redraw Slim with a 0.3 fineliner, making those legs as skinny as you possibly can (even down to just one line!). Add lots of whiskers and teeny pupils looking left (cuz that's what makes him look so shady!!).

Fig. 5 Paint a uniform wash of orange over the entire body and head. Let dry. I bet if you painted this guy pink he'd look just like the Pink Panther!

ways to level-up Shady Slim!

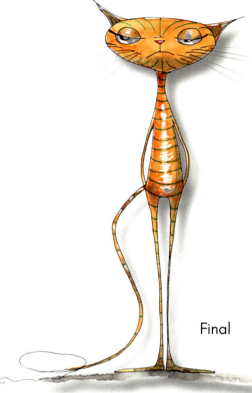

Final

Final With a soft pencil, scribble in his ears, under his chin, down with side of his body and on his feet and tail. Then use a blending stump to moosh that all together. With a green gel pen, draw stripes down his whole body. Your last move will be to scribble **white** all the way down his body middle and on his eyelids! Having the white in the middle and shading down the sides make both regions appear to bulge out! Which is pretty comical considering how slim Slim is!

Let's make: stunned stanley

What you'll need besides a pencil and watercolor paper:

watercolor brush

fineliners with permanent ink

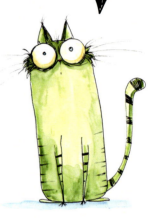

micro brush pen

121 FERN | 122 SPANSH MOSS | 123 VINE LEAF | 124 EARLY SPRING | 125 BALSAM | 126 WILLOW TREE

 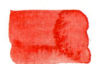

127 BLUE SHADOW | 128 SOUR WOOD | 129 CRAB-APPLE | 130 MAPLE | 131 PURPLE SMOKE TREE | 132 SASSAFRAS !

colors from the Terrain Watercolor Set by Prima

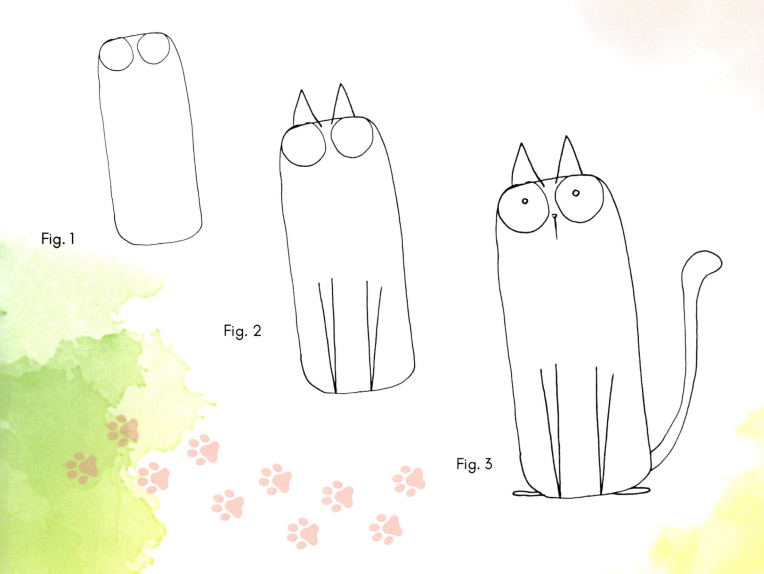

Fig. 1
Fig. 2
Fig. 3

Fig. 1 Draw a tilted, rounded edged rectangle with 2 perfect circle eye-balls!
Fig. 2 Add pointy triangle ears, and even pointier triangle legs!
Fig. 3 Add 2 tiny pupils, nose and just a straight line for the mouth. Now add 2 flat outward facing feet and a tail off to the side.

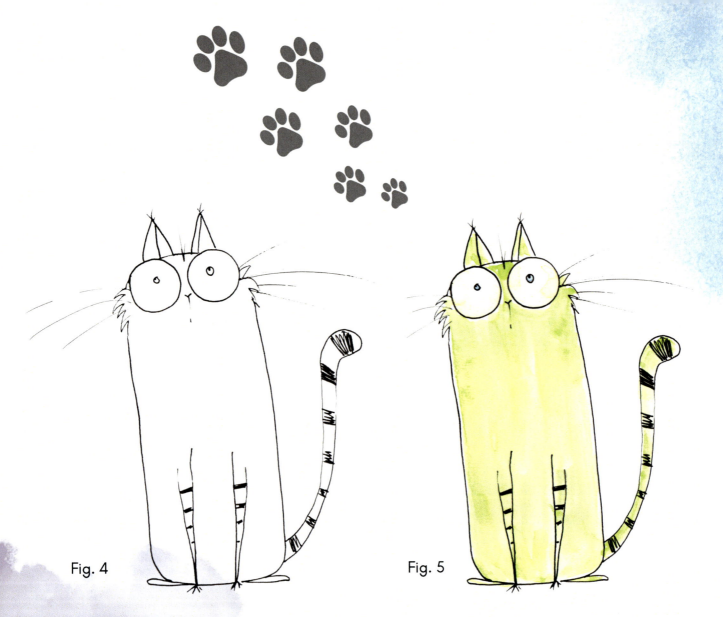

Fig. 4

Fig. 5

Fig. 4 Now add some fluffy fur bits to either side of his face and some whiskers too while you're here! Add stripes to the legs and tail with a gel pen. Scribble them in for a loose look!

Fig. 5 Do a wash of green all over! Super easy!

Ways to level-up Stunned Stanley!

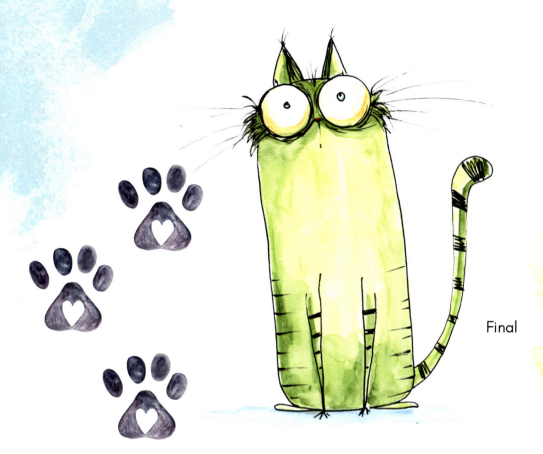

Final

Final With a darker shade of green add another layer of watercolors around the eyes and along the sides and bottom of tail. Then loosely add the same darker shade to the bottom area and legs. Finish by scribbling around the eyes with a micro fine brush pen in black. Add as many more wacky whiskers and stripes as you'd like! And the very last move is to add a swipe of yellow to the bottom of each eye. That will make it look like his eyes are REALLY 3D and really truly stunned!! Oh Stanley!

Let's make: Grumpy Gus

What you'll need besides a pencil and watercolor paper:

watercolor brush

gel pen

white gel pen

Pentel brush pen

umbrella for poor Gus

85 SAND RIDGE
86 SHADOW
87 CAVERN
88 FOX BERRY
89 POND
90 STREAM
91 BEAR
92 MIST
93 GREY STONE
94 DAY LIGHT
95 RED WOOD
96 DEEP MOSS

colors from the Woodland Watercolor Set by Prima

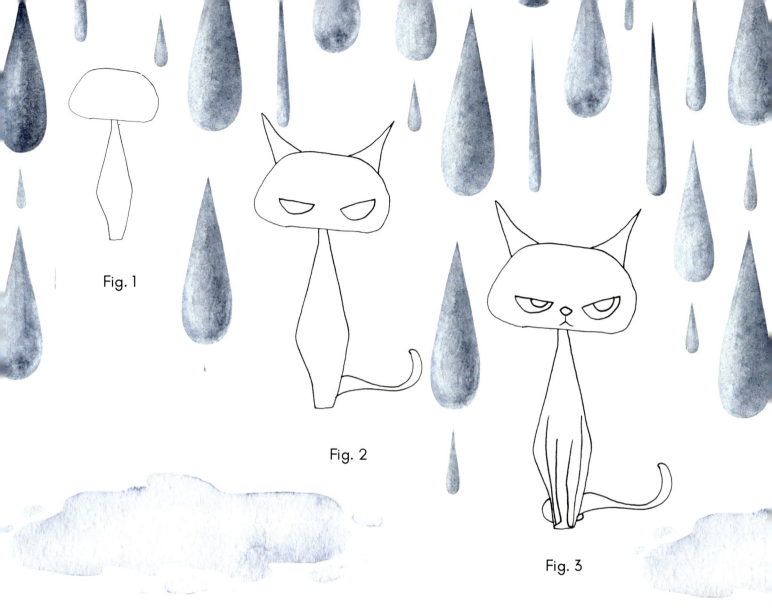

Fig. 1 Draw an big wide oval head and then add an almost diamond-like shaped body.
Fig. 2 Add 2 cute pointy ears, 2 half circles low down (eyes), and a tail.
Fig. 3 Fill in the pupil, bitty nose and simple, down-turned mouth. Draw 2 simple and straight front legs, a tiny bump out on the right and a larger one on the left.

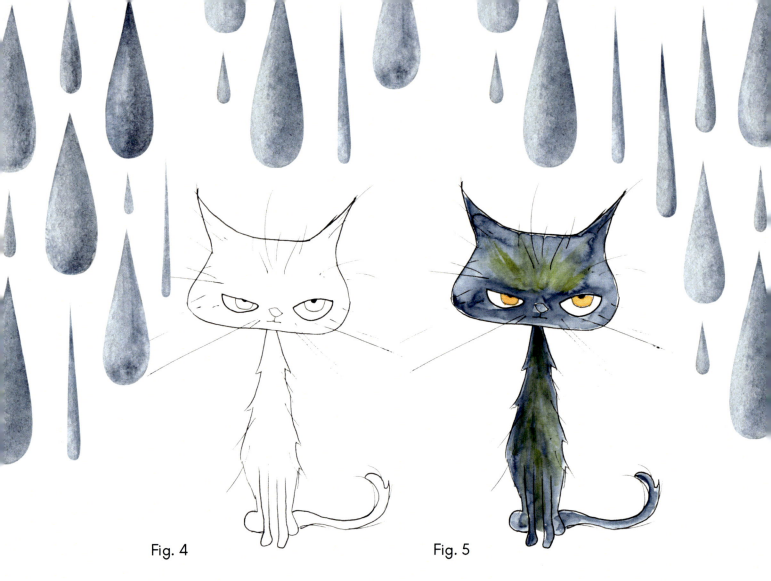

Fig. 4 Fig. 5

Fig. 4 Now let's switch from pencil to gel pen (or fineliner) and trace your first lines of the outline only add little spikey bits (almost like a Christmas tree!) to represent the fur. With a small fineliner make little wacky whiskers shooting out every which way.

Fig. 5 Use a dark blue watercolor to fill in cutie little Gus. While it's still wet, throw in some green too!! Add green above the eyes and down the body center.

art.awesomeartschool.com/wacky
To see EXACTLY how to get his edgy look!!

Ways to level-up

Grumpy Gus

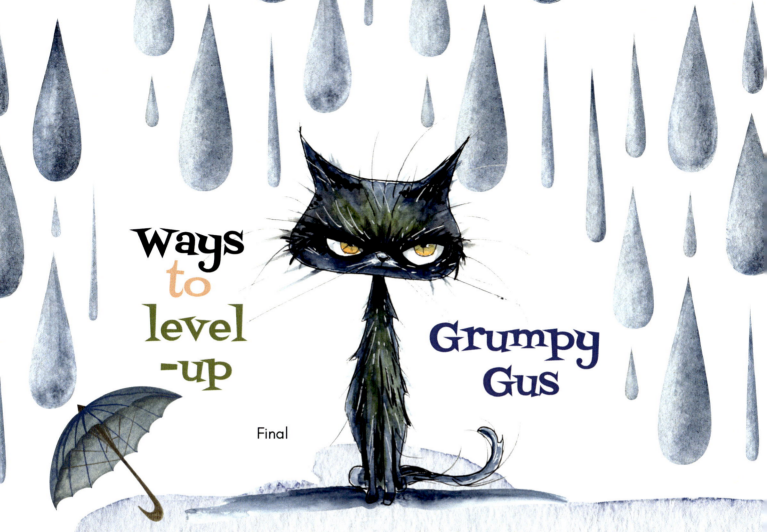

Final

Final Before you put away your watercolors, do another coat of the blue all over, and this time paint whiskers with the watercolor too! Let dry. Then, to make Gus look appropriately grumpy, we need to add some black in there to match his dark mood. So with the bigger Pentel brush pen, outline the area around his eyes, under his neck, and on either side of his front legs. Also add some fur inside his ears while you're there. Lastly, use a white gel pen to make pointy short whiskers and fur. Add white to the tip of his nose and on either side of his wee muzzle. NOW he's ready to take on the world! You've got this Gus!!

Let's make: Lanky Lou

What you'll need besides a pencil and watercolor paper:

watercolor brush

fineliners with permanent ink

fine brush pens

gel pen

01 WHITE

02 PINKY

03 RED

04 ORANGE

05 YELLOW

06 GREEN

07 ICY BLUE

08 BLUE

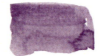
09 PURPLE

10 COCOA

11 GREY

12 BLACK

colors from the Classic Watercolor Set by Prima

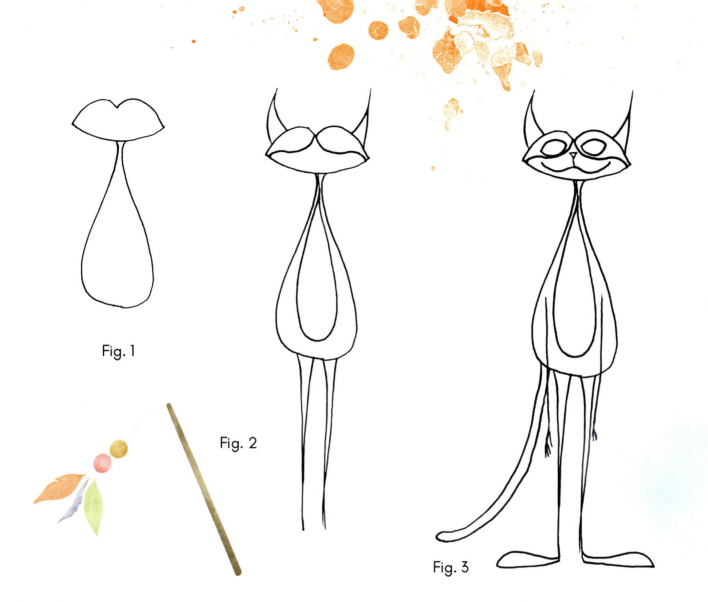

Fig. 1 Draw lips (right?) but skip the middle line. Add a tear drop body shape.
Fig. 2 Add super pointy ears, raccoon-eyes, a tear drop within the larger one and then 2 of the skinniest legs in the whole world! They literally come to a point!
Fig. 3 Add 2 arms that are just ONE line (the skinniest of skinny!) long and end in some baby lines for fingers. Add eyes, feet, a tail, and a smiley face.

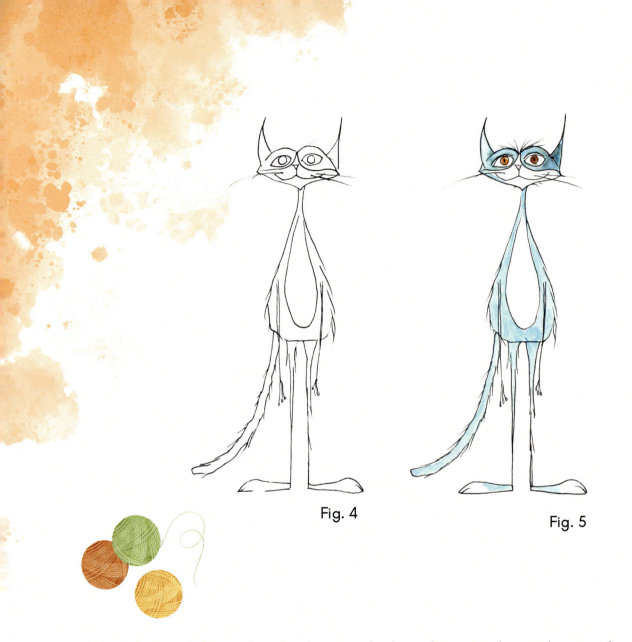

Fig. 4

Fig. 5

Fig. 4 Now redraw with a fineliner and when drawing the outline, make some hairs ever so often. Erase your pencil lines. Add some whiskers!

Fig. 5 Paint him all in with a light blue. Make his eyes orange so they really stand out! Keep his tummy, muzzle, and toes the white of the paper for now.

Ways to level-up Lanky Lou !

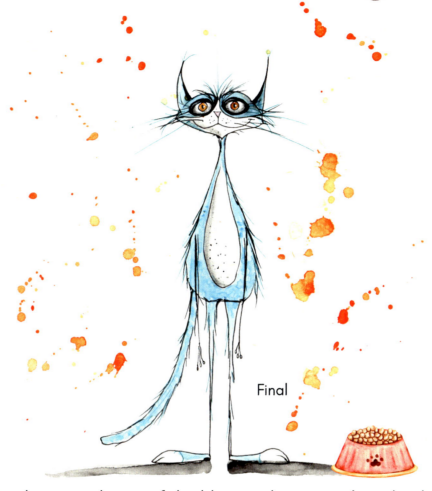

Final

Final Add a splotchy second coat of the blue just because it's such a happy color! Circle his eyes a bit more in pen so they stand out. Using a blue micro brush pen, add individual hairs going out every which way. Add some more whiskers too! Now use a soft pencil to scribble around the left side of his tummy and face. Use a blending stump to smooth it out. For extra fun, make huge wet splashes all around him with that orange eye color!! Revel in the messy goodness of it all!

Let's make: Mad Marley

What you'll need besides a pencil and watercolor paper:

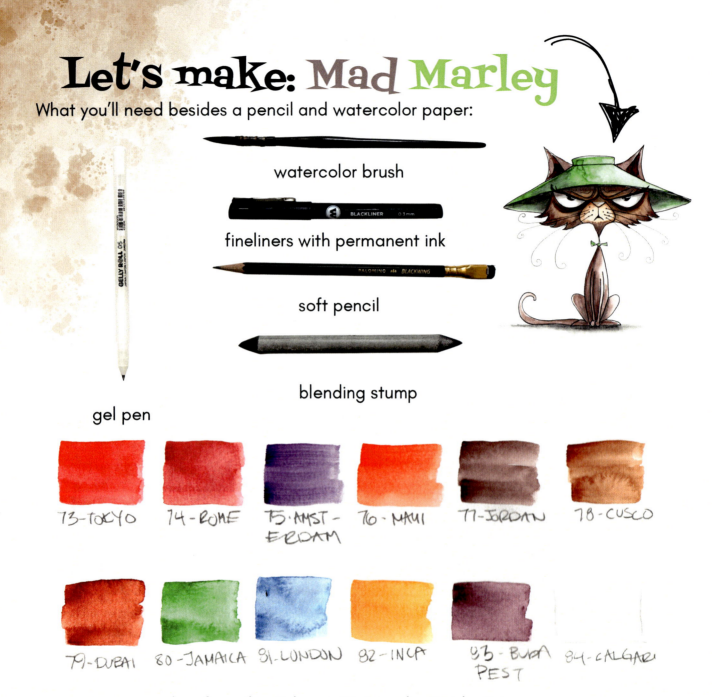

- watercolor brush
- fineliners with permanent ink
- soft pencil
- blending stump
- gel pen

73-TOKYO	74-ROME	75-AMSTERDAM	76-MAUI	77-JORDAN	78-CUSCO
79-DUBAI	80-JAMAICA	81-LONDON	82-INCA	83-BUDAPEST	84-CALGARI

colors from the Odyssey Watercolor Set by Prima

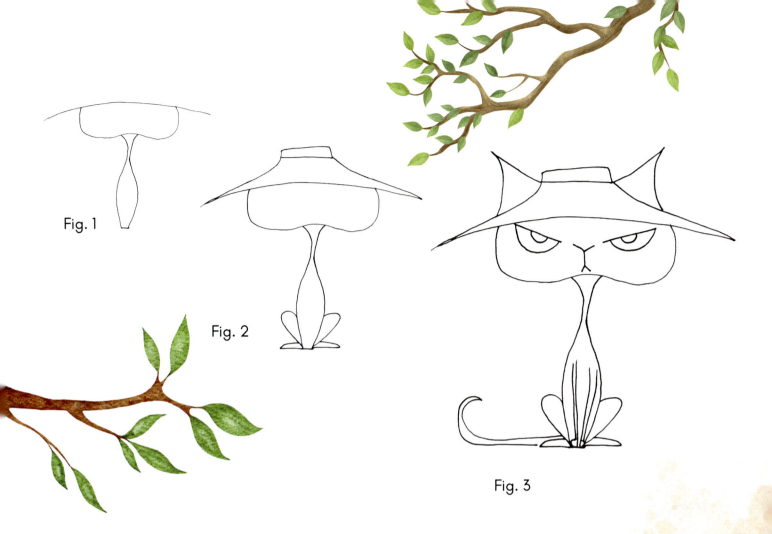

Fig. 1 Start by drawing a sloping, long, horizontal(ish) line. Add a bulgy curved line below. Then tack on what looks like a skinny vase (I mean it does, doesn't it?).
Fig. 2 Complete the hat by adding slopey lines and capping it with a little box on top Add 2 loops on either side of her vase-body and you're ready for the next step!
Fig. 3 Add eyes (making sure they are slanted in so she looks mean), a simple nose, mouth, and tail. Finally, add straight skinny legs ending in baby circles at the bottom.

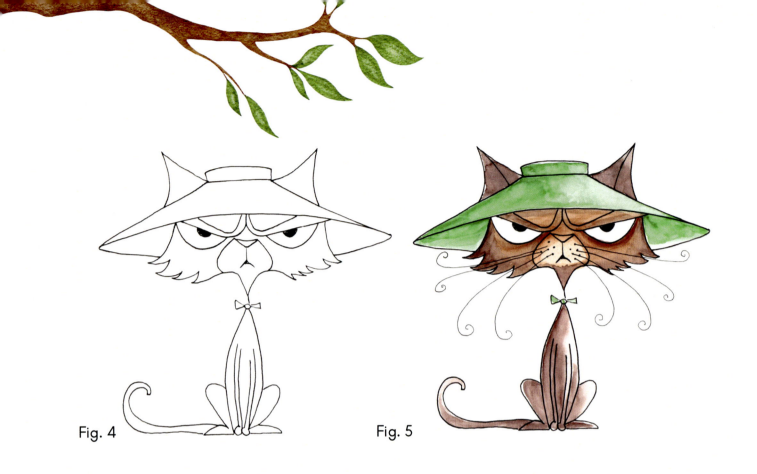

Fig. 4 Fig. 5

Fig. 4 First let's use a pen to redraw the edges of her face, making the edges frayed out like fur. Finish drawing the hat and add 2 perfect triangles for ears on top. Be sure to add the extra curved lines over the eyes so she looks REALLY grumpy! Add the wee bow.

Fig. 5 Using green (or any color you fancy her hat to be) to paint all over the hat. Use a paper towel to lift off some of the color on the right upper side. Use Jordan over her whole face and body, keeping the right side also light. Add some bonus whiskers; they're one of her best features, you know!

Ways to level-up Mad Marley!

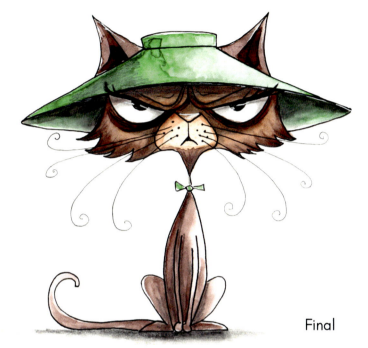

Final

Final Paint another coat of the same green to the left of the hat on top and then along the top rim. Add a second coat of Cusco around her eyes and along the bottom part of her face trim. Then add a second coat of Jordan over her left side. Now take a soft pencil and scribble some graphite along the underside of her hat, under her body, on the outside of her legs. Be sure to smudge some around the corners of her eyes too! Then take that blending stump and moosh it all out nice and evenly. Slice the white gel pen across her nose and pupil to make her extra slightly evil. I wish I knew who's making her so mad??? Shady Slim maybe? Yeah that guy looks like a trouble maker...

Let's make: Nerdy Neil

What you'll need besides a pencil and watercolor paper:

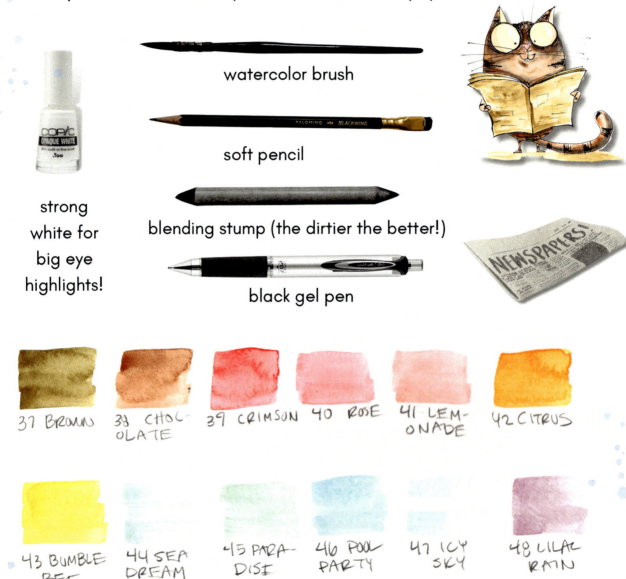

- watercolor brush
- soft pencil
- blending stump (the dirtier the better!)
- black gel pen
- strong white for big eye highlights!

37 BROWN
38 CHOCOLATE
39 CRIMSON
40 ROSE
41 LEMONADE
42 CITRUS
43 BUMBLE BEE
44 SEA DREAM
45 PARADISE
46 POOL PARTY
47 ICY SKY
48 LILAC RAIN

colors from the Pastel Dreams Watercolor Set by Prima

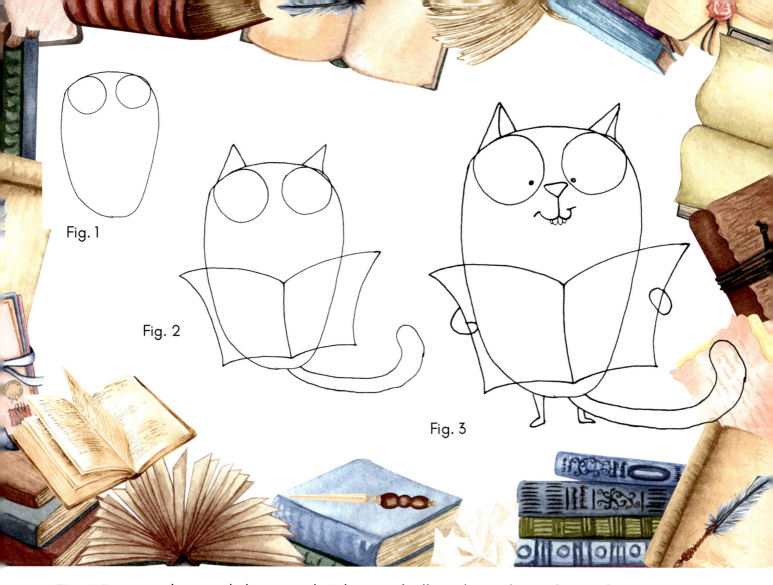

Fig. 1 Draw an big oval shape with 2 big eyeball circles right at the top!
Fig. 2 Add 2 little pointy triangles for the ears and a mildly swerving tail. Then draw 2 sloppy rectangles coming together in a straight(ish) line, halfway down the body.
Fig. 3 Make the 2 pupils, nose, goofy grin with 4 ridiculous tooth made out of loops. Draw little legs and feet and simple hands (so simple there are no fingers!).

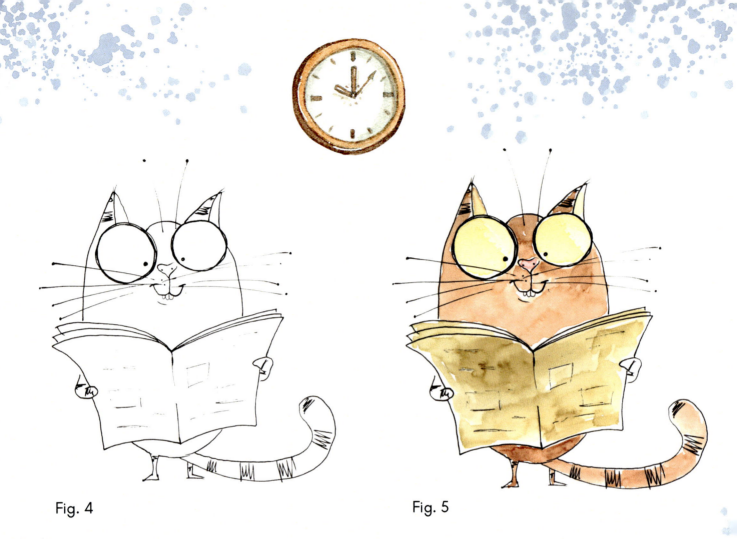

Fig. 4 Fig. 5

Fig. 4 This stage looks like a lot but it isn't, promise! Just add little squiggles for stripes with your gel pen all around our little guy. Add some whiskers that end in a dot (cuz why not?). Make some boxes and lines on his newspaper so he's got something to nerd out on.

Fig. 5 Just swipe over his whole body with brown. Use another shade and put a sloppy layer over the newspaper. Then add a watery yellow to the eyes. Dap a little spot of pink on his nose and you're ready to rock and roll your next moves!

Ways to level-up Nerdy Neil

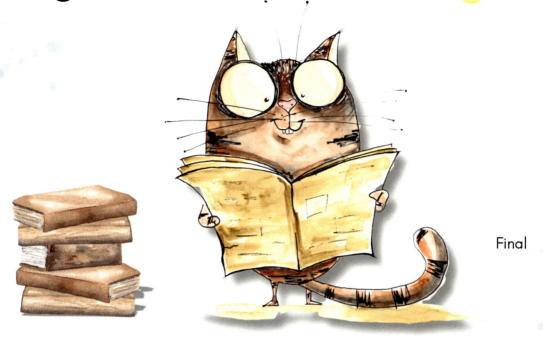

Final

Final Nows the time to let loose with that gel pen. Add some scribbles around his eyes and you can add more stripes to his sides if you like, maybe dress up the edges of that newspaper! With a soft pencil you can add shading to around his eyes, outside of the paper (top and bottom) and all along the underside of his tail. Just because he's a cartoon doesn't mean he deserve some accurately place shadows! Then use your blending stump to smooooth out those pencil marks, add a dash of white to the right sides of his eyes and call it a day!

wanna share your Whimsical Watercolors?!
Cuz I wanna see them!

Note: The cover art for my Group changes from time to time. Don't be alarmed if the art you see looks different than this one :)

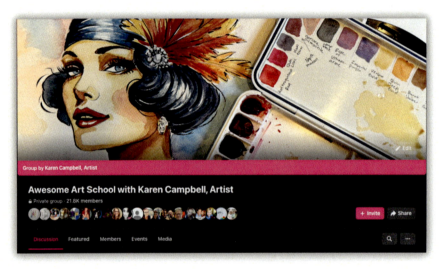

 ## Join my FREE Facebook Group Community!

Every time you upload a photo of your Whimsical Watercolors (or art inspired by any of my many art books) use the hashtag **#karensartbooks** and you'll be automatically entered to win a FREE art book of your choice OR a pencil pouch!

Winners are chosen on the first of every month, enter as many times as you like! Good luck and I'll see you at **www.facebook.com/groups/awesomeartschool**

more books by the author

Visit Amazon for the most up-to-date selection.

Look for more in this series!

about the author

Karen Campbell is a full-time multimedia artist, instructor, business owner, and author of over 20 art books. She is the founder of **AwesomeArtSchool.com**, where she teaches online courses in drawing and painting to beginners and aspiring artists.

Her two YouTube channels (Karen Campbell MIXED MEDIA and Karen Campbell DRAWS) feature over 600 free art tutorials.

Originally from the Boston area, she now lives in North Carolina with her computer-geek husband. She's a mom to three amazing kids and lots of crazy fur babies.

Karen loves to have a good time and is positively addicted to teaching art because the joy it spreads is wonderfully contagious!

"Don't think about making art, just get it done."
— Andy Warhol

Spread the love by sharing this book with a friend, and if you enjoyed it, please consider leaving a 5-star review on Amazon. Your support helps others discover the joy of art too. Thank you! 🙏

Whimsical Watercolor
& How to Draw Series
by karen campbell

wonky woofers edition

Book 3

Keep your eyes peeled on Amazon book shelves for more in this series!

Made in United States
Orlando, FL
08 December 2024